THE
VANISHED

THE VANISHED

THE "EVAPORATED PEOPLE" OF JAPAN IN STORIES AND PHOTOGRAPHS

LÉNA MAUGER AND STÉPHANE REMAEL

TRANSLATED FROM THE FRENCH BY BRIAN PHALEN

Skyhorse Publishing

Skyhorse Publishing books may be purchased in bulk at special discounts for sales promotion, corporate gifts, fund-raising, or educational purposes. Special editions can also be created to specifications. For details, contact the Special Sales Department, Skyhorse Publishing, 307 West 36th Street, 11th Floor, New York, NY 10018 or info@skyhorsepublishing.com.

Skyhorse® and Skyhorse Publishing® are registered trademarks of Skyhorse Publishing, Inc.®, a Delaware corporation.

Visit our website at www.skyhorsepublishing.com.

10 9 8 7 6 5 4 3 2 1

Library of Congress Cataloging-in-Publication Data is available on file.

Cover adaptation by Rain Saukas
Cover photograph by Stéphane Remael

Print ISBN: 978-1-5107-0826-6
Ebook ISBN: 978-1-5107-0828-0

Printed in China

On the flip side of everything we think we absolutely understand lurks an equal amount of the unknown.

—Haruki Murakami, *Sputnik Sweetheart*

Prologue

It was my first big-kid bike with racing handlebars. I rode it around the neighborhood to build up my endurance. Before long I began to explore traveling on my own, thrilled by how far I could go. After an hour of pedaling, beaten by the wind, I could cross the Belgian border. There was still a border control at the time, but I avoided it by taking rarely used back roads. Who would think to question a ten-year-old boy?

Without much difficulty I could reach uncharted territory, a neighboring country with different rules, another currency, a strange language, and, within reach for a few hours, a new life, untainted by my past. For shelter, I claimed a nice stone ruin in the middle of a wheat field. I would stay hidden there for hours wondering who would find me if I died.

I also had a knack for disappearing at school. I would discreetly climb a tree. If I could hide myself quickly in the leaves, no one would think to look for me up there. I would often spend recess observing insects, reading, studying my

classmates' behavior, breathing. And sometimes I would come down only at the end of the day, long after the end-of-recess bells had rung.

While growing up I regularly distanced myself from my ordinary life to go live another one, quiet and free. As a teen I took to the road with my camera, first by bike, then by motorcycle and plane, to immerse myself as deeply as possible in the unknown parts of the world and of myself.

All too soon it came time to get back in line and abandon this freedom in favor of the routine of social conventions. I took a hard look at my life and came to a pretty clear vision of the meaning of our urban lives—that there wasn't one.

I was losing it. I was wavering, torn between a desire to end it all and a fear of causing my family to suffer. I refused to make them feel guilty about my death. It would be better to abandon everything, to take a long trip and never come back. To disappear, making the most of life for a few more months, killing time on the other side of the world. Then covering my tracks without leaving a trace. It seemed like a feasible idea. I would leave in autumn.

Seasons passed; my plan remained buried.

And just as water trickles down into the earth, love returned to nourish me. I rediscovered the will to live. I returned to the road without slipping away.

Some time later, hot on the trail of the evaporated people in Japan, I confronted those who had changed their identities and shut the door on their lives. While investigating with Léna all over the country, I realized how attached I was to what I had so badly wished to flee.

Stéphane Remael

Suburb north of Tokyo:
an ideal place to hide,
disappear, escape.

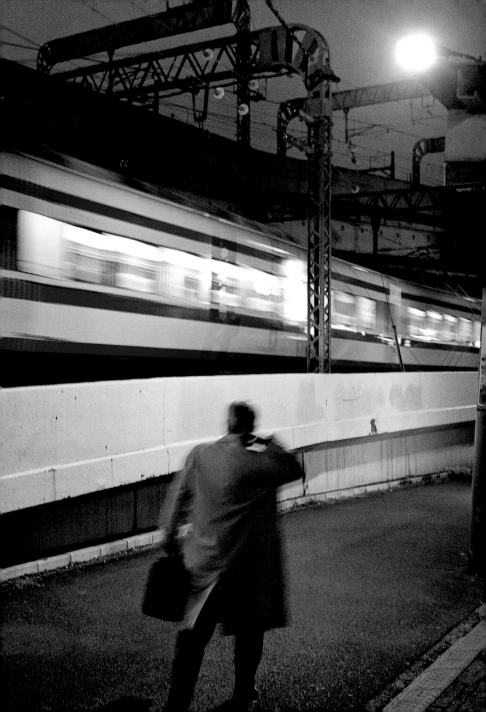

1

Through a moonless night, a shadow glides under the rare streetlamp. The suburb, north of Tokyo, drifts off to sleep in the icy air, lulled by the humming of the trains. Overshadowed by skyscrapers, this modest neighborhood is a collection of low houses, deserted sidewalks, and a few unchained bikes leaning against covered cars. The ideal place to hide, disappear, escape. At the bend of an alley stands an impersonal white-cement cube of a building, the facade crossed by ideograms indicating the business name: "All-Purpose Waste Collection Company." Men are busy unloading three vans parked in front of the ground-floor warehouse.

One of them, small and stocky, comes forward in the darkness—"The boss should be here soon." He slips away, then returns a half hour later to show us an outdoor stair-case leading up to the boss's office. A mess of papers, old

computers, typewriters, walkie-talkies . . . The boss is hidden behind stacks of files. Suddenly he stands up, slim body, serious face, and bows to introduce himself: "Kazufumi Kuni." He points to some fold-out stools and has a brief incomprehensible exchange with my interpreter.

He then ceremoniously pulls some yellowed pages from an envelope nestled on a shelf, setting them down one by one, various documents and letters as well as an identity card. Kazufumi, born April 16, 1943. In the youthful-looking photo, there is a man with ambition in his eyes. But these documents portray someone who no longer exists. Since then, his face has wrinkled, his last name has changed. A phonetic mutilation, at once a scar and metaphor for his life.

That man left his home one day, never to return. Like thousands of Japanese—men, women, entire families— Kazufumi chose to live as one of the country's fugitives. But he used to be convinced the world was his oyster. At age sixty-six, he looks back on a well-structured past. With a degree from a prestigious Japanese university, he once worked as a broker, in charge of managing high-risk transactions.

"I was a *topsellerman!*" he exclaims in English. Elegant and up-and-coming, the man had one project after another.

Until the day that, after a bad investment, he recorded a sudden loss of 400 million yen (over $3 million). His clients hounded him; his bosses blamed him for the losses. The disgraced broker felt like he was on the brink of ruin. From deep inside him rose a powerful force that engulfed and destroyed him. It was not a matter of strength but of deep-seated shame. One morning in 1970, with no plan and no warning, he took the train and vanished. Pure and simple.

At first he hid in a working-class neighborhood of Tokyo, at the home of an old university classmate. For several weeks the two men, perfect strangers, shared a small apartment. Hidden away, Kazufumi went silent and thereby began his evaporation.

Wandering led him into the cracks of the capital where, like everywhere else, unscrupulous employers can be found. In order to survive, he accepted humble work, making some 8,000 yen, or sixty-five dollars, a day, just enough to cover his basic needs. From builder to laborer, dishwasher to waiter in a cabaret, he toughened "physically and psychologically." That life taught him to become a vagabond, a man without a past. "I didn't think about a new life, I just ran away, that's all. There is no glory in running away. No money or social status. The important thing is to stay alive."

His loved ones did not forget about him, though. He got wind that his panic-stricken father was leading an investigation in the mountains where he grew up, distributing missing person flyers, even hiring a private investigator. The debt collectors also looked for him and threatened his father before finally giving up. You cannot take a missing person to court.

After years of wandering, he managed to rent an apartment anonymously, and discovered in the newspaper that there are companies that connect individuals with *benri-ya*, or handymen.

These small businesses provide all sorts of services: from plant watering to dog walking, even evictions. At thirty-eight, inspired by this concept, Kazufumi set up a modest company, the All-Purpose Waste Collection Company. The former gifted child got an official "waste collection" license, authorizing him to transport anything and everything. Starting from nothing, he began with dogs that had been run over, stinking, rotting corpses eaten away by vermin. The things people ignore as they walk past them on the street. Overcoming his own disgust, he resigned himself to doing this dirty work. He had to survive. The experience taught

Kazufumi left his home
one day, never to return.
"I didn't think about a new
life, I just ran away, that's
all. There is no glory in
running away."

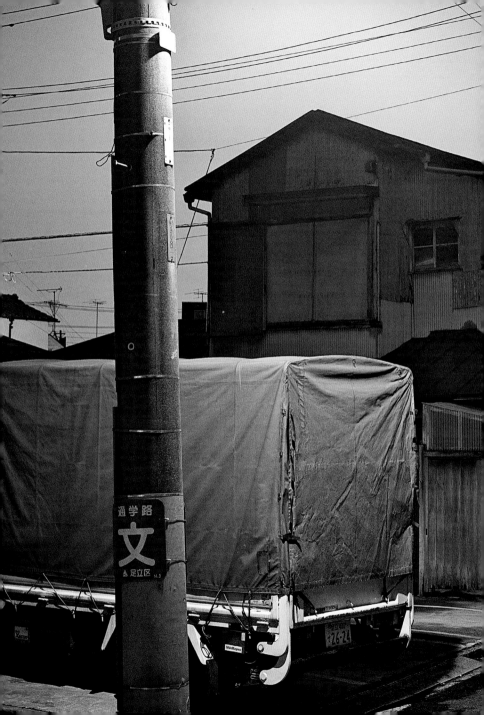

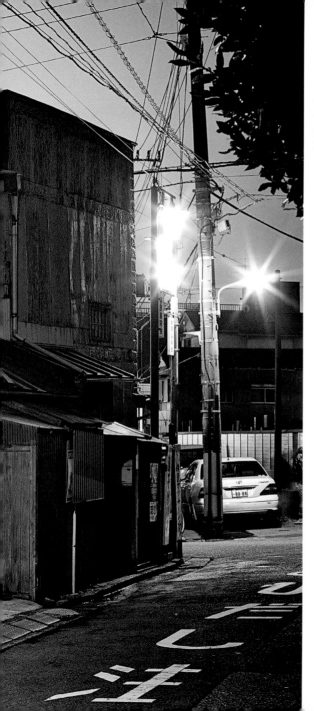

At twilight, vans discreetly take the runaways to a secret location.

2

Piercing the air like an arrow, the high-speed train hurtles west of Tokyo between a peaceful Pacific Ocean and Mount Fuji, that eternal subject of veneration for the Japanese. All over the world, this perfect white-peaked cone, a dormant volcanic mountain, symbolizes the Land of the Rising Sun. A hostess in a tailored suit goes up and down the aisle with sweets and, like on a plane, indicates the exits with a delicate hand gesture. The Japanese tell how, on the day of the train's unveiling, the first passengers left their shoes on the platform before stepping into the car. They were very surprised when their shoes were not outside upon arrival.

A few minutes before reaching the city of Atami, our interpreter motions to us to gather our things. I met this chubby filmmaker on the cusp of retirement on a rainy day in a Parisian café; he was recommended by a friend. I was

looking for someone who could facilitate my reporting in Japan. For hours, Guy energetically described his wife's country: the feminine gentleness, the elegance of movement, the feeling of security, the efficiency of public transportation, and all the little things that, for him, make Japanese living so serene.

Night was already falling on the Place de Clichy when he briefly mentioned a strange phenomenon: every year, thousands of Japanese people leave their homes and never return. Some take their own lives; the bodies are never found. Others become shadows. Violent death or oblivion—there is no other solution. No country in the world, he said, has as many "evaporated" people. Investigating vagabondage, disappearance, and vulnerability in a country of 128 million people seemed like a crazy and exhilarating challenge. I discussed it later that night with Stéphane, who was just as fascinated. And there we were, two months later, foreign to this enigmatic culture, our only compass being our guide's perseverance in the face of shadows . . .

The seaside resort of Atami, with its view of Mount Fuji, is famous for its *onsen*, or volcanic hot springs. The tradition began in seventeenth-century feudal Japan and

has lasted over the centuries. Collective imagination took over, associating hot springs with the destinies of the evaporated. Books, films, and plays tell the adventures of runaways coming to wash away their pasts in the sulfurous steam of the baths before being reborn elsewhere. Even the term "evaporated"—*johatsu* in Japanese—stems from this physical metaphor.

On this autumn Saturday, the neighborhood near the train station is bustling. Women in kimonos hand out advertisements for the hot springs. From their booths, old women sell the town's specialties: dried fish and kidney bean cakes. One serves grilled eel. Her bottom warmed by a stove, she happily discusses the Fuji baths. "You have to go visit the ones at the Taikanso Hotel, up on the hill. They are Atami's oldest. They were constructed in 1928. Go back up the street and turn left after the bridge . . ."

"And the *johatsu*, the evaporated. Are there any in Atami?"

With an about-turn, the old woman cuts off the conversation, suddenly silent, concerned only with rubbing herself to keep warm near the heat. At the police station, the police will not have any more to say. At the Taikanso Hotel, management sends over an engineer in coveralls who anxiously

takes me aside. "There are no evaporated people here," he says, his eyes on the lookout for eavesdroppers. "We used to be in need of labor, so we'd hire every applicant. But now we look into the person, where they come from, their family . . ." On that note, he turns and walks away.

With its twisting streets, industrial port, concrete pier, and deteriorating hotels, the seaside resort of Atami is as industrial as Brest and as touristy as Palavas-les-Flots. Old-fashioned and relaxed, the place does not exude mystery. Guy chose it for its legendary springs, but there is no trace of missing people here. And everywhere we go, my curiosity about the evaporated arouses the same unease. "But we're a respectable establishment!" the manager of a bath protests. "It's just a legend," insists another. Guy excuses them: "The evaporations are a taboo subject, people are ashamed to talk about it." This wall of silence intensifies my fears: would the phenomenon be as hazy as it is inflammatory? Can someone really vanish from the modern world today?

A hotel manager, hunched behind his desk, finally provides some information. "Maybe Doctor Uchida, the physician of the springs, could help you . . ." This Doctor Uchida runs a community clinic in the center of the little town.

In the entryway, about thirty pairs of shoes, all small sizes, indicate the children's day. In the crowded anteroom, visitors can expect an hour wait. The doctor sees his patients in his office, a sanitized room where the nurses bustle about. In a green smock, mask on his face, he expresses himself simply and frankly. "People come here because the springs of Mount Fuji have been famous for centuries. They rarely kill themselves after their bath. They generally roam around the city for a few days." In a nurse's arms, a child whose chest is being listened to starts to cry, imitated immediately by another. Doctor Uchida raises his voice over their cries. "Some of the evaporated find work in the *ryokan* [inns], as cleaning staff, for example. It's no secret that the springs attract runaways, dishonored people, criminals . . . The locals haven't forgotten Kazuko Fukuda's escape. The murderess was on the lam for about fifteen years after killing her coworkers, and the police traced her to the Atami springs. It was a scandal." A colleague loses patience at his side. "If I were you, I would go to the baths that are open day and night, near Shizuoka . . ."

Shizuoka means "calm hill." Although it is closer to Mount Fuji, the city is not very charming. Its seventy

thousand residents live in a world of warehouses and high-rise blocks in the center of which a brand new block stands out: the Hananoyu Onsen. In this enormous sanctuary of leisure and consumption, a soft carpet leads to restaurants, arcades, and movie theaters arranged around the baths. Only two hours from Tokyo, this is paradise for the residents of the capital who cannot wait to bring their families here for a weekend trip.

The manager, Mr. Taruno Uchino, is proud of his temple of wellness and wants to give us a tour himself. Impeccably dressed, in polished shoes, he stresses the "heated marble" floors, the "salt and sand" massages, the "state-of-the-art" sauna, and the restaurant menus. Relaxed among the red velvet cushions of an alcove, he boasts again of the benefits of his establishment. We must put an end to his litany. "Have you ever dealt with the evaporated?"

Taruno Uchino chokes on his tea. "The evaporated? Here? Uh . . ." He hesitates, for a while. "We often have people on their own, in a family crisis, that, yes. They leave home and don't know where to go. The advantage here is that they don't really risk running into anybody they know. And we are open twenty-four hours a day."

"What types of people are they?"

"I don't know. It's none of my business."

Mr. Uchino stands up and smoothes out his suit. "What's certain is that our treatments are a good remedy for lost souls." We return to Tokyo with hardly any notes.

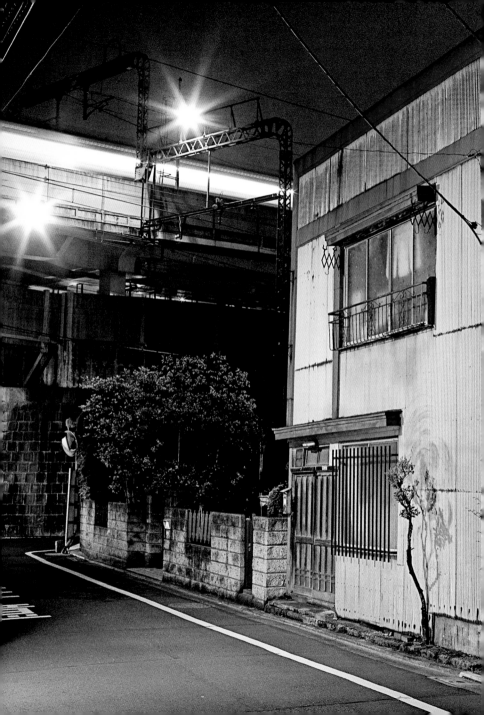

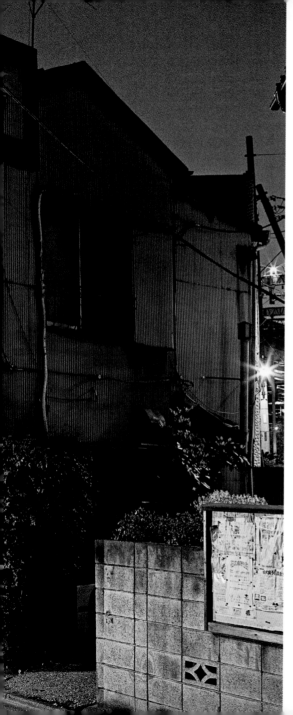

The Japanese flee their debts, but also the shame of a divorce, being fired, and all sorts of failures.

In the collective imagination, runaways come wash away their mistakes in the steam of the baths. Even the term "evaporated"—*johatsu* in Japanese—stems from this physical metaphor.

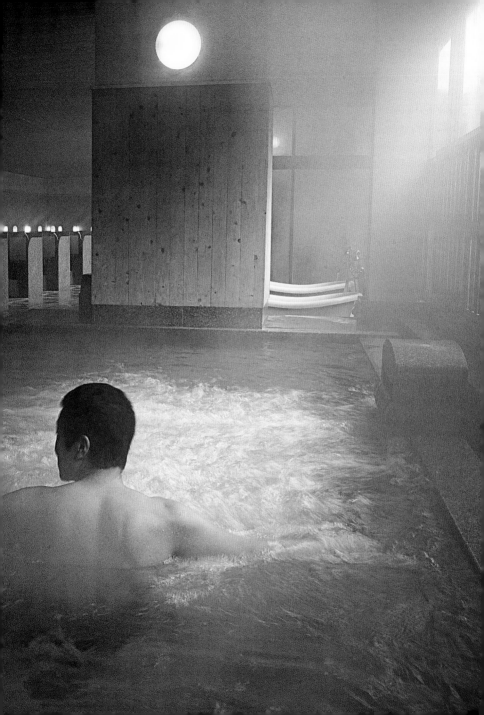

The evaporated often hide out in Tokyo and other big cities where the anonymity guarantees a certain invisibility.

were an old phenomenon, but they increased in the 1990s," Takahito Hara insists.

The show is as joyful and grotesque as a Hollywood made-for-TV movie. Tearful goodbyes complement the twists and high-speed chases that became the norm for the team at the Rising Sun consulting firm. "Using humor, I wanted to point a finger at a problem the media didn't dare talk about: the responsibility of the mafia in the evaporations." Takahito Hara mentions the entrance of the yakuza into legal matters during the economic bubble, when the price of a square meter of real estate doubled every month. During those golden years, mob bosses would openly frequent the best restaurants and play golf with the politicians, financiers, and industrialists who would give them a seat on their board of directors. They traded favors with each other.

In a country where the space is filled to the point of suffocation, businessmen relied on the yakuza to evict people from their apartments, then demolish them and build new ones. Those who refused compensation in exchange for their property were met with retaliation. Henchmen would defile apartment doors with various waste or excrement as escalating warnings. Others would park outside the apartment buildings in small trucks equipped with loudspeakers blaring political slogans, generally those of the far right.

During the financial bubble, average Japanese people across the board were borrowing *sarakin*—abbreviation for *salaryman kinyu*, or employee loan—from finance companies. Many of these instated annual interest rates that could exceed 100 percent and worked behind the scenes with the mafia. The yakuza were responsible for collecting debts; any late payments would hike up the debt and the threats. They themselves owned some of these credit institutions, to the point that the loans of millions of Japanese were baptized *yamikin*, "money owed to the yakuza."

Unable to settle their debts, many preferred to flee. The disappearances reached a peak of 120,000 per year by the mid-1990s. For the first time, the media caught on to the topic. Informal moving companies multiplied. To be careful, the *yonige* were carried out at night. In Japanese, *yo* means "night," and *nige*, "to run away." A *yonige* refers to the discreet escape leading to the disappearance.

In order to reenact these nocturnal escapes, the director of *Flight by Night* took details from local news stories. "Our fiction is very realistic." He also consulted a specialist on the phenomenon, who had come back from the shadows into the light. He agrees to give me his name, and a few days later I secure a meeting in Yokohama, a dynamic and overpopulated port city on Tokyo Bay. Again, the crowded

commuter train crosses an endless urban area at breakneck speed. Clusters of signs worthy of Las Vegas; highway overpasses; new, small houses made of particleboard; shopping centers; electric wires; and pylons blur as they parade past. Thirty kilometers on, it is impossible for us to distinguish one city from another.

Shou Hatori waits around the corner from the train station, in the immaculate lobby of a hotel. He heads to the bar and orders a soft drink. Small, muscular, with carved features, he looks just like a yakuza: silver chain, black jacket, vigilant gaze. For nine years he ran a moving company, a small, standard business, until the day that, in his favorite karaoke bar, a woman asked him to make her "disappear" along with her furniture. She said she could not stand her husband's debts, which were ruining her life. Shou accepted.

After that, the young manager seized the opportunity and posted a listing titled "Nighttime Movers." "A wink," he tells me. The clients understood immediately. The stock market had just crashed, and requests came rushing in. Shou took on the role of a savior, assembled henchmen and runaways in his office, drew up maps on a board, researched the best hideouts, imagined every scenario. He charged 400,000 yen, or $3,400, for his nocturnal escapes, three times the price of a normal move.

Salarymen, students, housewives addicted to shopping and luxury brands: all of these indebted candidates had the same goal—to escape their creditors. But debt is not the only reason people decide to evaporate. Shou Hatori also moved young students who had failed an exam, jilted wives, graduates exhausted by a life of chores in communal dorms. The one-night magician always knew how to keep secrets. He concedes simply that his clients were ready for anything in order to disappear, without a word to their families. His encouragements to hang in there were no match for their determination.

Then Shou grew tired of the car chases and the gloomy stories causing them. Like the hero of the film *Sonatine* by Takeshi Kitano—a retired yakuza on Okinawa Island—he decided to change his life and publish his account of the evaporations. Released in 1997, *The Yonigeya* has the intensity not of a Scandinavian crime novel but of real life. In Japan, the United States, and Europe, the press caught on. Shou still introduces himself as a "writer, producer, and manager" and maintains that "his" runaways are living happily. He likes to think he is morally justified. "People often associate *yonige* with cowardice. But while doing this work, I came to understand it as a beneficial move."

Since then, Shou has given up the underground life. If he is to be believed, his runaways are free, hidden away in

the shadows, having wiped the slate clean. He cannot disturb them now. It is impossible for him to contact them again, even less possible for him to introduce me. As we part ways, Shou calls over his seventeen-year-old daughter, a karate champion, smartly dressed in a pleated skirt, her hair in braids. Her father has big plans for her. "She is going to be a movie star." This will be his revenge on his own history. Because he, too, was one of the evaporated, as a child, after his parents fled Kyoto and their debts . . .

For nine years, Shou Hatori ran a nighttime moving company that helped people disappear.

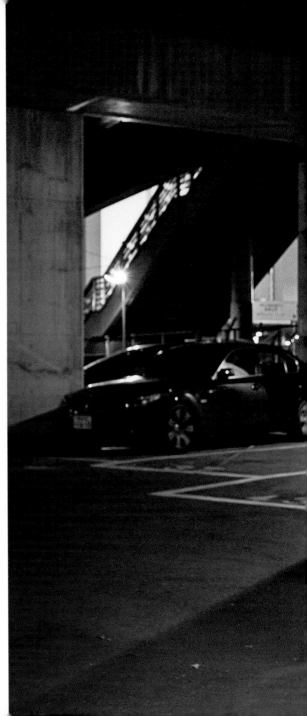

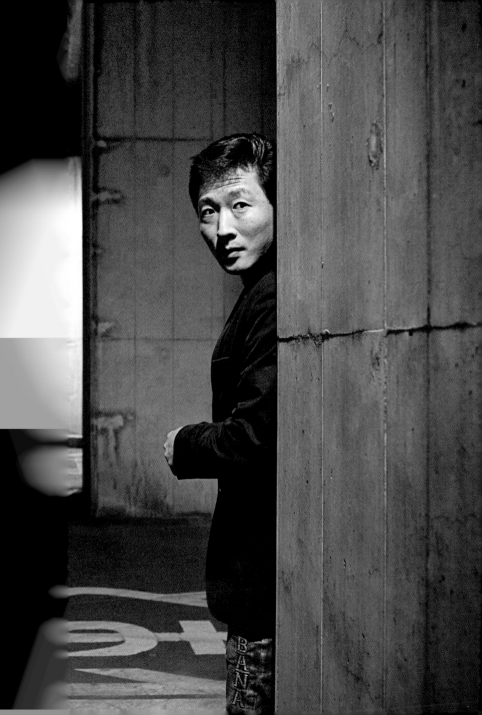

4

Hashi
Evaporated for twenty-six years

"The mud has seeped into my shoes, I move ahead slowly, I talk to the trees. I imagine the telephone that rings in the empty living room, my furious boss, my wife in tears. And then my father, pragmatic as always, who has surely already hired a detective. The apartment searched, mail opened: what does the detective think, other than that I am a weak man?

"I walk for two days, my feet muddy, my clothes damp, a pit in my stomach every time I hear an animal. A forest at night is an awful thing. I got off the train at the foot of Mount Fuji and disappeared into the Aokigahara forest, attracted by the legends, lava traps, compasses that no

longer point north, magic fog, hopeless people coming to kill themselves under the shroud of nature. Aokigahara is nicknamed 'Jukai,' sea of trees. I am swallowed up by its dark and dense waves.

"I see myself hanging from a tree, and the grimace of the man who will find my rotting corpse. My life flashes before my eyes—rich childhood, exemplary education, promising engineering career. I am an only child, and I don't recall really enjoying myself in our house, too big for three people. I would already be asleep when my father came home, and when my mother picked me up from school, she always looked sad, nostalgic. Sometimes I was afraid she wouldn't be there waiting, as if deep down I had the feeling she dreamed of a more thrilling life and that, one day, she would go for it.

"The trees dance with the wind, the rain washes my skin. What is left of my marriage? She in a white kimono, her long hair I love so much up in a perfect chignon—she was one of the prettiest girls at the university; the boys were all crazy about her—and I in a navy suit bearing the family coat of arms. My boss toasts to love, to work, to my promising talent, to the future halls of shopping centers and offices we will get off the ground . . .

"My wife and I live in a two-room apartment on the southern border of Osaka, a white living room with a splash of red, a copy of a painting by Rothko, her favorite painter. She doesn't want kids, not yet. She wants to take advantage of her youth. 'Take advantage' is quite the expression; we don't do anything remarkable since I am often at the office nights and Saturdays, and I only have ten vacation days a year. She volunteers part time at a gallery, paid like an intern, so it is fortunate that I make a good living.

"She is home alone. Someone rings the bell. Standing on the landing are two men in dark suits. They are brief. 'A public works company is going to replace your apartment building with a taller, more modern building. You have to leave,' they say. Same situation the second time: the shorter one in front, the other, big and well-built, behind, with a curt, threatening message. My wife immediately calls me at the office. The next day, I find our mailbox smashed in. At the time everyone speculates that the investors are ready for all illegalities to force out homeowners. She and I, we both know it. Many of our neighbors have already moved out.

"She packs her bags, panicked, and leaves for her parents'. As for me, after working late into the night, I come

home and slide under the covers, alone. My mind starts to wander. I could sell the apartment; I'm not attached to it. It's not complicated to sell, but at the moment, it seems as difficult as swimming across the ocean. I think of my father, who paid for half of it, not without criticizing the choice ('Not well situated, too dark, too small . . .'). Nothing ever suits my father; nothing I do is good enough. He never misses an opportunity to remind me that, at my age, he was already an engineering project manager. We don't connect, we never connect, as if there are brick walls between us.

"Moving in with my in-laws is also inconceivable. What a failure. I'm stuck: the big arms will come back, beat me up, and throw my body into a garbage dump. I ache, my head hurts, I'm working too much. I recall that when the dawn rises behind the Venetian blinds, I'm lying down, counting the little stains on the ceiling. It's only after I make my decision that I transcend the fog. As if having a new goal brought me back to reality. I shower and tidy up the books in the library, the bouquet of dried flowers at the center of the white table. I write, 'I feel guilty, I'm leaving. I'm sorry for putting you through this. Don't wait for me. I will never forget you.'

"That note torments me in the forest, in the wind and rain. I have a rope in my bag; I came to end it all.

"The bag remains on a pile of dead leaves.

"I leave my keys, my money, and I continue in the cold through the sea of trees. I fight off sleep. The forest howls at night.

"The weather is nice. I open my eyes. An old man is leaning over my face. He gives me some soup, rice, grilled fish. He is dressed in a big sweater and watches me in silence while I eat. I'm probably not the first one he's found.

"I recover my strength. I don't want to impose. He gives me some cash and watches me go from his doorstep. With my own coat, hat, and shoes washed by the old man, I board the train for Tokyo. I'm no one, neither me nor anyone else.

"At dawn I find myself outside a shed, automatically, as if I had been there before, as if a voice told me where to go—the voice of survival. Some awkward guys motion for me to get in their van. And there I am, day laborer on a construction site, similar to the ones whose blueprints I was finalizing just a few months earlier. The work is hard, the pay reasonable—no papers to fill out, no risk of being found. The trucks bring us back at night, but there

are also longer assignments—two weeks, even a whole month.

"We all sleep in camps, a perfect place when you don't have an address. One time, there was a police raid, looking for criminals. Fortunately, I was in a bar that night, and I didn't have to give my name.

"The crisis comes, the bubble burst. I have nothing left to hope for in Tokyo. I want to go back to Osaka. I want something else. My city has changed; the chimneys and factories gave way to high-rises.

"I get a job under the table in a dry cleaner and rent a room, similar to the one I live in today, clean and bright, too. At night I roam around the illuminated city. I like to feel my heartbeat, its energy, its music. I often dream about my wife; I think I see her silhouette in the crowd. My life is made up of simple pleasures.

"Then the dry cleaner closes. It starts all over: the feeling of failure, the shame, the exhaustion, the overactive mind. The fall is quick. I have the impression I'm watching it from the outside. It's not me, not yet. I'm losing my teeth. Suicide is inevitable. I am a renegade, a broken cog in a big machine. Faceless, useless. A life like this will drive you crazy. At some point, I will go crazy. But I am lucky. In spite of everything, I am lucky.

"One night, I am going to look for my soup bowl under a bridge, not far from where I sleep, completely drunk, and I accost a volunteer. She laughs this time, she looks at me—I mean she really looks at me. I feel like it's been centuries since someone has looked at me like that, like I'm a man. Just like that, I exist. I am alive. I feel my body—tired. We talk a little under the bridge, between the passing cars, and we continue chatting the next Thursday, and the one after that . . . It must seem silly to you, but these little exchanges give me a reason to get up in the morning. Before long I help the volunteers serve soup. They also give out hot coffee and used clothes.

"My friend recommends me to the manager of a restaurant who is looking for someone to do a bit of everything: shopping, dishes, cleaning. It's a tavern with four tables and a bar. It only opens at night; its varied and well-priced cuisine attracts the locals. One day I tell the manager everything, and she accepts me just as I am, with my spotty past. 'When are you calling your wife?' she often asks.

"I took the plunge two years ago.

"Seeing someone again, when you are sure you want to, also means asking yourself what you might dig back up. I slip on an ironed shirt and a dark jacket. I can't see

her; it's too hard. So I go knock on the door of her brother, my brother-in-law. He opens the door. He hasn't moved. He has developed wrinkles and a belly, but I recognize him right away.

"I say my name, and he slams the door in my face, as if I were a thief. I ring the bell again, and he comes back a few minutes later with his wife. They both stare for a long time at the toothless man standing before them, and I know that's what strikes them the most, this monstrous mouth. They whisper, dumbfounded, 'Yes, it's really him.'

"I had forgotten that their apartment was so luxurious, soft, comfortable. I simply forgot comfort. I didn't anticipate their reaction at all, perhaps hoping for a little warmth, but on the contrary they are very awkward, spilling tea, stammering, looking at each other for some hint of how to behave. My sister-in-law has a nervous little laugh. My parents are dead. My father first, then my mother. Cremated. A lot of people at their funerals.

"My whole body tenses up, like after a shock. I'm disappointed, and now it's me who has difficulty breathing—it nearly hurts—before asking about my wife. Remarried. A long time ago. Two kids, the husband a university

professor in Osaka. She couldn't stop looking for me, couldn't stop crying. With no trace of me, ten years after my disappearance, she declared me dead. What was I expecting?

"Since then I have been dying slowly. When happiness is lost, it is never recovered."

A homeless person hides along the side of a road near Tokyo Bay. Like the disappearances, poverty and discrimination remain taboo topics.

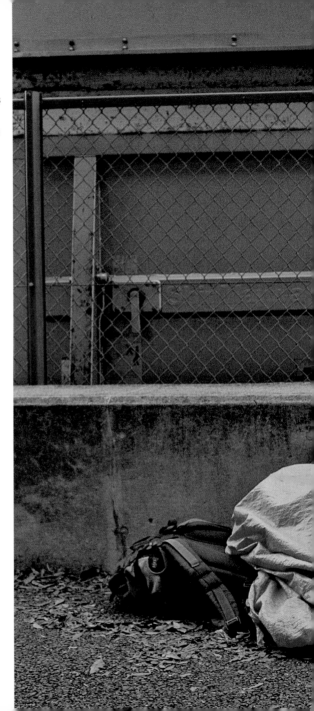

advantage of the need to keep up appearances, the distress it causes, as well as the feeling of loneliness poisoning society. Nicolas suspects some companies are employing runaways. Since you are already lying to yourself, playing someone else is hardly unexpected.

Nicolas was introduced to me by one of his colleagues, a friend we met at the French cultural institute in Tokyo, where Stéphane had been invited to stay and exhibit his photographs. From our tiny room above the train tracks, we overlook, as if perched at the bow of a ship, the cultural organization's imposing white building. As we wait to find leads on other missing people, we decide to investigate these two-bit priests. We meet Bob, a restaurant owner; Filipe, a Franco-Portuguese textile importer; and Marlon, an English teacher who, upon his return to Australia, will put an end to the deceit by actually entering the priesthood.

On the phone, the boss of a rental company justifies his business. "I don't feel I'm insulting the Church by sending fake priests to weddings. The demand is there. Seeing as the priests do their jobs well, it's a business like any other . . ."

A priest in Tokyo is very much against it. Another smiles, seeing the trend as a small revenge the Church is taking after failing to convert the Land of the Rising Sun in the seventeenth century. During an expat dinner, a practicing

Catholic puts the hypocrisy into perspective. "In France or the United States, a lot of people are married by real priests and half of them end up divorcing. The Japanese, on the other hand, are a lot less likely to separate. Real or fake priest, if the couple isn't serious, the marriage will fizzle out, right? And then again, what is a real priest?"

The day after the dinner, Guy meets us at the French Institute of Japan, triumphant. He was able to convince some of the evaporated to talk about their disappearance. As protocol dictates, he went to their home the first time alone. You must introduce yourself first to best organize a meeting. Planning, codifying, all to avoid the discomfort of the unexpected: a well-oiled diplomacy that turns nightmar-ish for impatient people.

These runaways live northwest of Tokyo, in a peaceful, working-class suburb where small houses seem to compete for what rare space is left. Their facades act as a canvas in the soft light for the shadows of people just returning from work. But no one can give us directions. Still, arriving early is a sign of respect, and we are about to be late.

Finally, Guy recognizes his friends' little house. Squeezed between two others, it looks rather modest. A mustached man in a big wool sweater greets us. In the living space—a poorly heated kitchen teeming with rickety sideboards, piles of dishes,

knickknacks, dolls, snow globes, and children's drawings—Ichiro distributes mismatched chairs. A few moments later, his quiet wife returns from work at the post office. She hurries to pull fish brochettes and little balls of dough covered in a sweet sauce from plastic bags. Pretty soon the table is set.

But the atmosphere is tense, the silence difficult to break. Motionless, the eldest son, Tim, stands rigid across from the table, intently examining the carpet. Upstairs, lying in her bed, the grandmother clears her throat. Ichiro and his wife face each other from either end of the table. They know why we are there. Bound by their promise to their French friend, the couple can no longer turn back. "We used to live among the cherry blossoms in Saitama, in the Kanto Plain . . ." With these words, Ichiro sets out on a journey into the past. The son of tanners, he became a kendo instructor at twenty and gave night courses to police officers. A success for a man of his milieu: kendo was the sword training of the samurais.

The martial arts master married Tomoko in an arranged marriage. The couple learned to love each other and planned, in the 1980s, to open a *gyoza*, or dumpling, restaurant. Ichiro took out a loan, but does not say how much. With the restaurant not attracting many customers and the country sinking into the recession, Ichiro and Tomoko began to worry about their home, especially as Tomoko was expecting Tim,

their first child. "It would have taken a century to pay off the debts." Ichiro's mother lived under their roof as well. It was her decision to quietly sell the house. They did not have the time to come up with other plans. Quickly, very quickly, the "nighttime movers" were called. On January 1, a stormy day of celebration, the Kurihamas disappeared.

Tim remains motionless, still standing, still stiff. Among the children, he is the only one who knows the secret. Tonight, his brothers, who grew up believing the picturesque family narrative—the cherry blossoms in bloom, the pretty house, the "voluntary departure" for Tokyo—were sent to friends' houses. Tim has stayed. He could tell the rest of the story: his parents' anxious expressions, the miserable years, his father becoming a builder, the silence that settles in as life goes back to normal and the fear subsides. "Our son is an enigma to us," Ichiro says. "He is like the calm surface of a lake whose depths you know nothing about. The other two are easier to understand, and they work well at the university." Tim, with his lip piercing, seems frozen in place. "I think I put too much pressure on him," says Tomoko, who puts a kettle loudly on the burner and tackles a heap of dirty dishes.

Ichiro seems tense. The man of the house nervously plays with his glasses. Just like that, all of the pain leading up to this moment breaks through: "In this house, *yonige* is a taboo word.

As if we were pariahs. But who can say he has never wanted to change his life? People are cowards. They all want to throw in the towel one day, to disappear and reappear somewhere nobody knows them." Tomoko sits back down, abandoning the dishes. Her husband lowers his gaze to the flowers on the tablecloth. "I never envisioned running away to be an end in itself. My mother taught me to overcome obstacles and be combative. But disappearing gave me a chance to be reborn, washed clean of my mistakes." He pounds his chest. "I'm aware of my weaknesses. I wanted, for example, to cancel this meeting today. It's not easy to open up, and in the end, what's the point? But I told myself this was a new challenge being presented to me. You know, a disappearance is something you can never shake. Fleeing is a fast track toward death."

Tim closes his eyes. His father goes on. "I feel tired, but I continue along my path, and I don't have any more reason to change my life. I only want one thing: to live peacefully with my wife and children. Until the end."

The man stands up in stony silence.

"Do you still do kendo?"

"No, but my sons have taken it over!"

Relieved, he pulls out a family album from a nook and begins to flip through it. Tim rushes toward a cupboard and takes out a collection of medals and cups, long since

pushed aside. Ten minutes later, Ichiro makes an extraordinary appearance. Tim looks at his father in admiration. "You look like a yakuza, Dad!" Loose pants, indigo jacket, mesh mask over his face, Ichiro swings an edged saber with surprising ease in such a small space. For the first time in twenty-three years, he has put on his kendo uniform.

Upstairs, the grandmother grumbles. She wants to watch. She needs to be helped down the stairs. Ichiro delicately seats her in a worn-out chair in the middle of the living room. The old woman gazes at her son, nostalgic.

Outside, the icy night has consumed everything, the houses and the telephone lines. Our breath blows away in vaporous clouds. Guy breathes quickly, and says, "I didn't know. I suspected it, but they'd never told me. Did you understand?"

"Understand what?"

"They are *burakumin*. Literally, the hamlet people. A little like the untouchables in India, they're at the bottom of society. Since the Middle Ages, there have been castes who are assigned jobs the Shinto religion considers 'impure': knackers, tanners, undertakers, and any other activity tied to filth, blood, and death."

"Even today?"

"Officially, no. Ever since the caste system was abolished in the nineteenth century, they can enroll in the civil registry and lay claim to the same rights as anyone else. But in reality, discrimination persists. They often live in ghettos or marginalized neighborhoods, marry within their communities, and are listed in secret directories."

"Do they have more reason to evaporate than other people?"

"A lot of them took out loans from the mafia because the banks refused to lend them money. Others work for the mafia to get out of poverty."

The Japanese hardly ever talk about this discrimination, but all of the minorities—Korean, Brazilian, etc.—experience it. Japanese culture has been strongly influenced by that of China, which spread from Vietnam to Korea. However, the insularity and isolation of Japan fostered the birth of a culture freed from that model, reinforced by a strong nationalism. Guy says he is struck by the collective feeling of being different and the racism expressed toward the non-Japanese. Once, on a street corner, he stumbled upon small trucks with loudspeakers blasting icy, nasal slogans: "Kill the Koreans!" "Koreans, hang yourselves. Drink poison. Go die!"

In the shadow of
Tokyo's skyscrapers,
these quiet suburbs are
modest collections of
low houses, deserted
sidewalks, and some
unchained bikes.

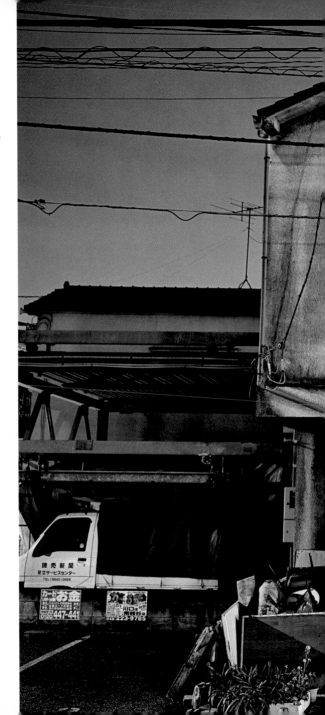

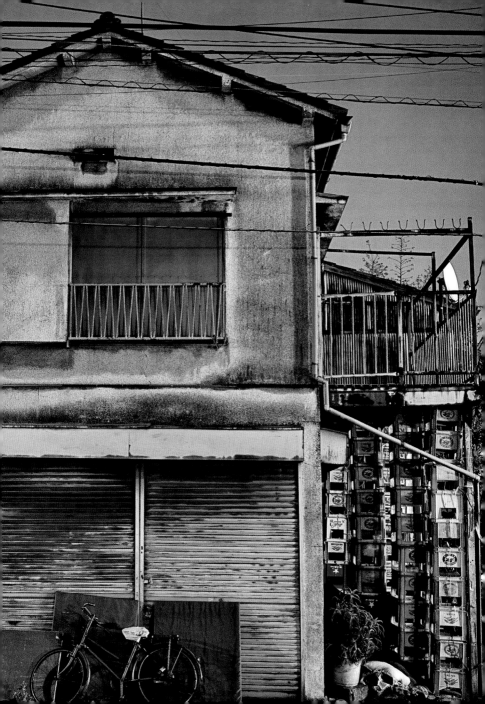

For the first time since his evaporation, Ichiro wears his kendo (a combat sport) uniform in front of his son.

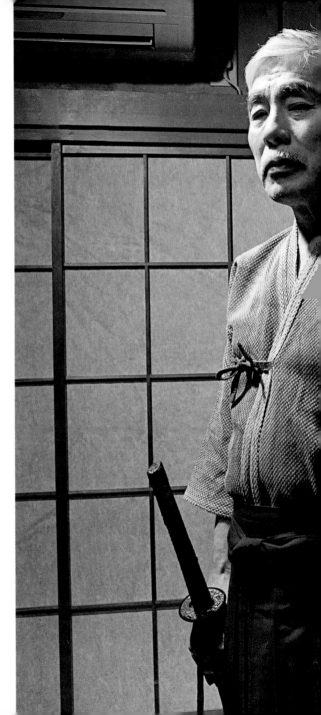

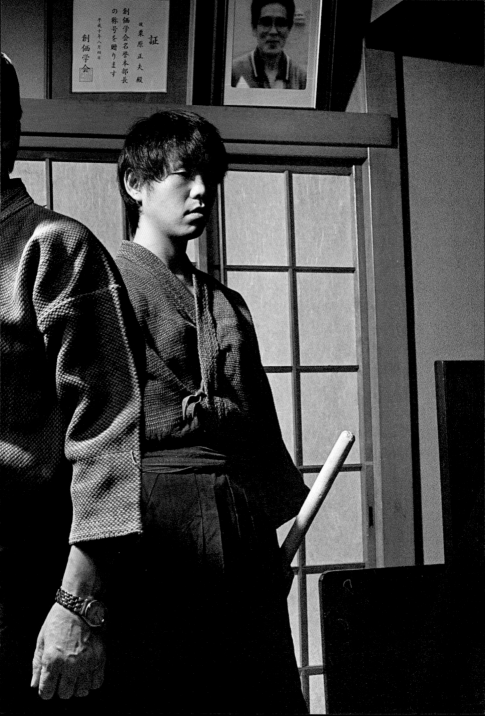

6

Kazufumi, the evaporator from the All-Purpose Waste Collection Company, disappeared one morning in 1970, and he has been lying ever since. He sunk into an administrative void. His hometown declared him missing. For a long time, his new town hall knew nothing of his existence. He lost his rights, deprived of social security. Nor is there a school for the children of the evaporated. It is possible here to hide in a modern, connected country, on the condition that you live in a parallel world. Kazufumi married without ever confiding his secret to his partner. The romance failed. How do you build—how do you build yourself—upon a lie?

He had told us about moving a lot of people within the city of Tokyo, where the anonymity guarantees a certain invisibility. "But I also took some to the country." A local journalist put Guy on the trail of one of these escapees, Shunsuke Soda, who withdrew like thousands of unemployed and disillusioned people from behemoth cities. Today, the Japanese government offers aid and grants to those who repopulate

rural areas, a little like how France seeks to bring doctors to "medical deserts," areas with no practitioners.

Shunsuke Soda left Tokyo seven years ago to settle in the Yamanashi province in northern Japan. At the train station exit, the forty-year-old man stands out because of his sporty jacket and urban style. His hands are white and smooth, his car spotless. Despite the fog, he tears along roads between forests and hilly fields. The trip ends on a dirt road, at the base of a wooded hill. Feet in the mud, he uses his finger to point out four big plastic greenhouses. "Spinach in winter. Tomatoes, lettuce, and strawberries in summer." A couple of farmers, in boots and covered in mud, harvest heads of lettuce on a neighboring plot and stare at him without a word. "They never say hello to me. They don't think I'm a real market farmer. They don't trust me."

It rains heavily, with no shelter nearby. Shunsuke does not want to take me to his place. "It's far, and I have to deliver my vegetables." He gets back in his car. "I used to be a salaryman like everyone you see in Tokyo, stressed and obedient to my company. I worked in a very big hotel, ten to twelve hours a day. I thought I would go crazy." Wedged in the driver's seat, Shunsuke tells his story. At his wits' end, he learns that the countryside is in need of labor. Rising to the challenge, he signs up for a six-month agricultural training program in

a university in northern Japan. He must also pay to relocate. "My father is very rich, but I didn't want to owe him anything. Since I didn't have any guarantees to get a bank loan, I went to a secured creditor."

The interest rates are too steep. Shunsuke cannot pay them back. Another failure. Evaporating becomes inevitable. "First, I took what was most valuable to me, then the movers came in a truck and took the rest." With the remainder of the loan, he rents a small apartment, a tractor, and tools. And begins working hard. The winters are tough and the loneliness intense, but in his greenhouses, the harvesting soothes him. Reluctantly, out of nowhere, Shunsuke admits only now to having done a *yonige*.

He parks the car in the courtyard of a beautiful, modern house. Strange: he said he lived in a small apartment. A seventy-year-old man in slippers appears on the front steps. "My father," says Shunsuke. The man bows and goes inside. His wife, who waits in the hall, had enough time to provide slippers for each of us. The parquet floor is luminous; the interior, bourgeois and Western: everything is smooth and tidy. In perfect English, Mr. Soda invites us into the living room. "I was the director of a multinational. I'm retired these days, but I regularly do assignments for big companies." His elegant wife brings coffee and biscuits. "This house is our second home. We had it built

last year. Before that, we lived in a hotel. But a house is a lot more comfortable. And our son can use it. It's better here than in your little apartment. Right?" Shunsuke remains despondent on the couch. Like a child after an argument, he crosses his arms tightly against his chest.

"Mr. Soda, what do you think of your son's change in lifestyle?"

"Personally, I could never have done that. Working the land isn't for me. But Shunsuke is young and healthy. Here, he eats well, he exercises. It might be complicated once he gets to retirement age, but I trust him. He can handle it."

Feigning affection, Mr. Soda tries to grab his son by the shoulder. Shunsuke shrinks away. "Of course, I was surprised when he told me he wanted to become a farmer, but I've always supported him. Isn't it true that I've always supported you?" Now the father speaks for his son: "He needs to find a wife. Not easy in this hole of a place. There are only farmers."

It is time to leave. Another energetic slap on Shunsuke's back, a few steps down the stairs. Mr. and Mrs. Soda watch the car go until it disappears on the horizon.

"I don't understand. You live with your parents?"

"No, I told you I have an apartment, but it's small and not very welcoming. My parents insisted in order to keep an eye on me."

Shunsuke really tried to free himself, to become independent, to break away from his family, but they came back as inevitably as thirst. Deep down, the farmer felt he had to reassure his parents after four years of silence. His father had the house built straightaway without even consulting him. Sullen, Shunsuke lets it all out: "I feel like a man on the run who hopes to live a normal life. I thought I had gotten distance, but I failed. My father is overbearing and intrusive."

Kazufumi, the evaporator, said he had to push his past aside and live from day to day without ties for at least five years. The boss of the All-Purpose Waste Collection Company went fifteen years without ever calling his parents. Paralyzed by fear. Fear that they would be in poor health or that they would have received threats because of him. They may have forgiven him. But Kazufumi never had the strength to see them again.

Yamanashi province. Some of the evaporated withdraw into the countryside. One of them, formerly in the hotel business, became a market farmer.

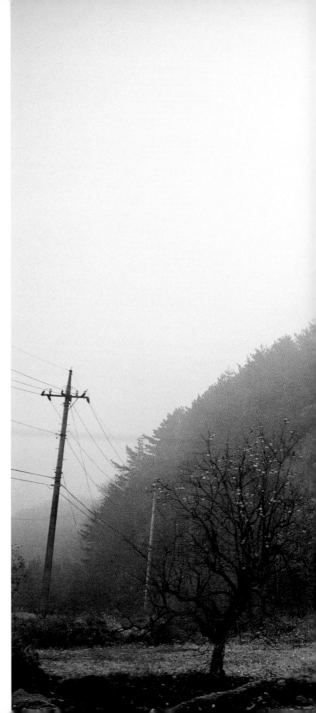

a mess. If I die tomorrow, I don't want anyone to be able to recognize me."

At forty, a handsome man, living with his wife but unfaithful, Norihiro was still a brilliant engineer. When he was suddenly laid off, he did not change his routine at all. Every morning, he slipped on his suit and leather shoes and left the house, his briefcase in hand. And every day, his wife wished him a good day, her hand on his shoulder. Outside his old office, from sunrise to sunset, he waited, without eating or talking. He kept this up for a week. "I couldn't do it anymore. After nineteen hours I was still waiting because I used to go out for drinks with my bosses and colleagues. I would roam around, and when I finally returned home, I got the impression my wife and son had doubts. I felt guilty. I didn't have a salary to give them anymore . . ."

On payday, Norihiro gave himself a close shave, waved goodbye to his wife, and took his usual metro line. But in the opposite direction. At the end of the line loomed oblivion. "It pains me to think that my parents looked for me. I hope they are doing well. Maybe they still think I'll come back. Maybe they're dead . . ." About his wife and son, Norihiro does not say a word.

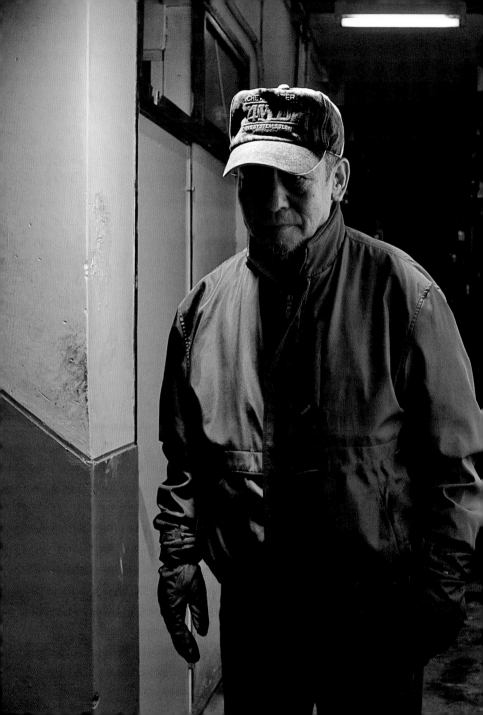

Like this man, who ran away from his family at sixteen, most of Sanya's inhabitants live in extended-stay hotels, small furnished apartments rented by the week or the month.

Sanya cannot be found on any map. This Tokyo ghetto, den of thugs and people of modest means, has left its mark.

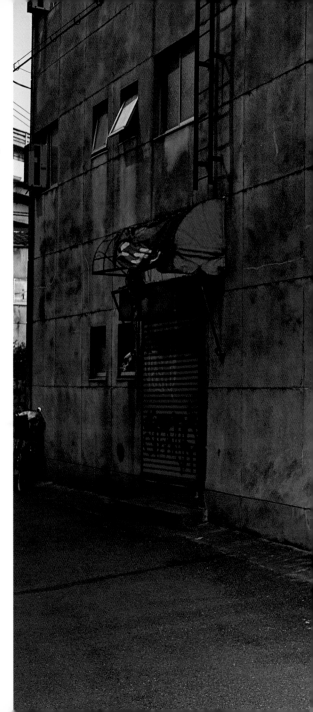

Masao, at only twenty years old, disappeared into the city after failing out of school and spending time in prison. He did not want to make his parents suffer the shame of seeing their son flout social conventions.

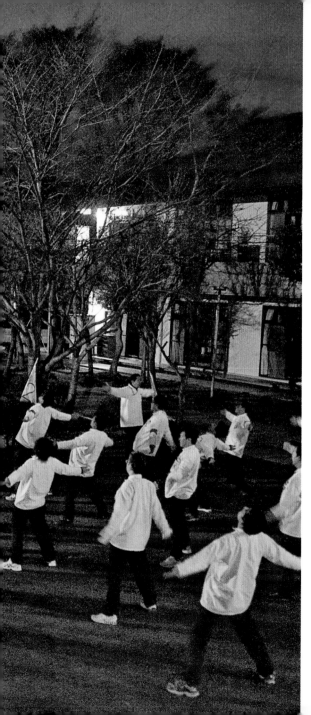

Physical exercises at the break of dawn for the trainees at the "camp from hell."

Here, senior executives must relearn how to read, write, talk, think, and act under pressure, like beginners.

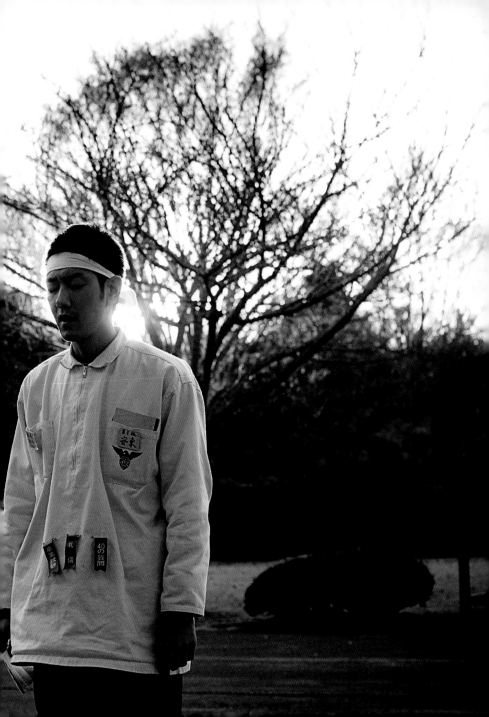

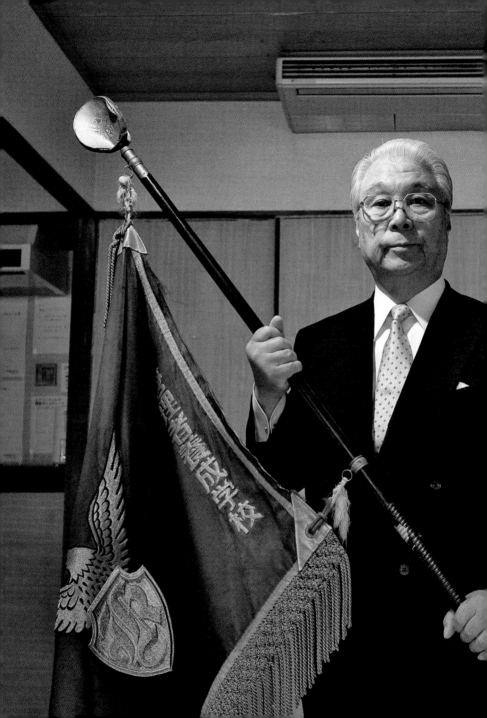

The founder of the school is also the lyricist of the hymn: "Sweat on our brow, what we have created, sweat on our brow, now we must sell it. You must not lose heart, crow salesman . . ."

10

At the foot of a colorful high-rise, a teenager dressed like a maid meets a candy-pink Lolita in a miniskirt, her hair in braids. In the Akihabara district, one encounters girls with cat ears, princesses with garter belts, robots running errands like everybody else, and *Dragon Ball Z* characters outside the metro. This curious caste has its home base, its planet, its Mecca. A Disneyland with free entry. The neighborhood, located in north Tokyo, is full of stores for buying manga, cartoons, and video games, as well as costumes to bring fictional characters to life. An elevator propels us into another world: in the middle of a shopping center, a glass café resembling a jar, with an English name, The Maid Café.

A "maid," a pretty brunette dressed in a red kimono, tells us about being born in a panda park. To thank me for ordering a seven-dollar lemon and mint cordial, she does the "heart dance" with her hands. Her fingers delicately bend into the shape of heart that bounces to the rhythm of her voice: "I serve you with love, mistress . . ." Her friend Picchi,

who brings a glass, also "with love," to Stéphane, her "master," is dressed up as Cinderella, perhaps her favorite character from childhood.

The "waitresses" all claim to be seventeen years old. Like Peter Pan, they will never grow up. And like fairies, they elude questions about real life. But they are all simultaneously studying at the university. "I am a dream. I sell dreams," says Picchi, walking away. A customer, who must have graduated a long time ago, waits for her in order to play with a plastic dog and little bones. He loses the game, but the maid makes eyes at him so he will play again. Handing over another bill, the man will retreat into his solitude with an autographed photo and the memory of a conversation about pumpkins and a forgotten glass slipper.

The Japanese have nicknamed these pandas, Cinder-ellas, and other people possessed by a passion the *otakus*, a term that comes from the Japanese word for "house" or "home." The term became popular at the beginning of the 1980s when it referred to people withdrawn into them-selves and their monomania: doll and fanzine collectors, fans of a manga character, people addicted to video games. One would estimate some three hundred thousand of these recluses living out their passions alone, holed up in a room, isolated on the Japanese archipelago. Far from crowds and

stares, they kill time, watch television, and surf the web anonymously.

A Japanese immigrant in Belgium, Aya Tanaka, directed a low-budget, intimate documentary on these voluntary prisoners, *Eau douce eau salée*. One summer, she decided to film her big brother, sick at his parents' house, whom she considered up until then to be "like a monster, a horrible person, who's fat, doesn't wash, doesn't shave, losing his teeth . . ."

One night when her brother lets her into his room strewn with beer bottles, Aya Tanaka discovers a boy "of physical force and huge intelligence," with "gentleness in his gestures," able to explain "the peculiarities of the weirdest insects," but who admits to feeling defeated by life. The boy does not have any more contact with his friends, no more social life. To his parents, he is but a shadow, a silent guilt. While Aya was finishing the editing of her documentary, he died, taken at thirty-eight by liver disease.

Since the 1980s, clubs and communities have been created, and the more extraverted *otakus* do not hesitate to parade in the streets despite the denigration that comes their way. A trainer in a company, Matt, thirty-six years old, slips on a white, inflatable costume that is half alien, half Michelin man, and flails around on stage two nights a week with his pop music group. Easygoing and straightforward, he claims

a right to leisure time. "I don't want to kill myself at work, to be a soldier of capitalism. So I do silly things, but they're fun." He brings up the strict education, the social obligation to always be the best at everything, the pressure his parents put on him to get married, the stress at work, and he quotes, to illustrate his resentment, a Japanese saying: "You must hit the nail that sticks out."

By projecting themselves into a parallel world, by inventing other lives, the *otakus* "disappear," Matt assures us. Running away is not always about leaving. We dream of love and freedom, and sometimes we make do with little, a costume, a song, a dance with our hands. In Japan, that is already a lot. "Our society doesn't let you be different. We assert ourselves through a character, we dedicate our lives to an idol," Matt says. Staying childlike, playing, fantasizing: so many defenses against a culture that leaves little place for the individual.

Tonight, Matt is giving a concert at the top of a modern apartment building, at Studio Cube 326. His costars, two wild singers, get ready in the wings: blue tights and blue contacts for one, a red outfit mounted with fake satellite dishes for the other. They boast: "Our parents don't understand us. They sacrificed everything for their company. They never had personal lives. We are eight-year-old androids."

Super-trendy girls, maids, Lolitas, sadomasochistic robots, and kittens will parade on stage until late in the night: visions, apparitions, as if they popped out of a manga. In the dark theater, a pack of fans cheer for their idols. An exclusively male crowd. Many have swapped their suits for an informal T-shirt and, in a chorus, shout the lyrics, imitate the choreography. Over the course of the night, they lie down, jump, meow, flog themselves on command. It is no longer a concert, nor even a fitness center, but rather a hallucinatory release. How many among them have already thought about ending it all? At my feet, Hiromoto, a forty-five-year-old mechanic, rejoices, dripping in sweat on the floor. Not a week goes by without a concert for his "kitten," his drug of choice. At home, he fawns over pictures, pins, and mugs of it. "It relieves my stress. My mind clears, and I can work off my energy. It gives my life meaning."

The evaporations
reached a peak after the
bursting of the financial
bubble in the 1990s. The
economic crisis of 2008
brought about a new
wave of disappearances
and suicides.

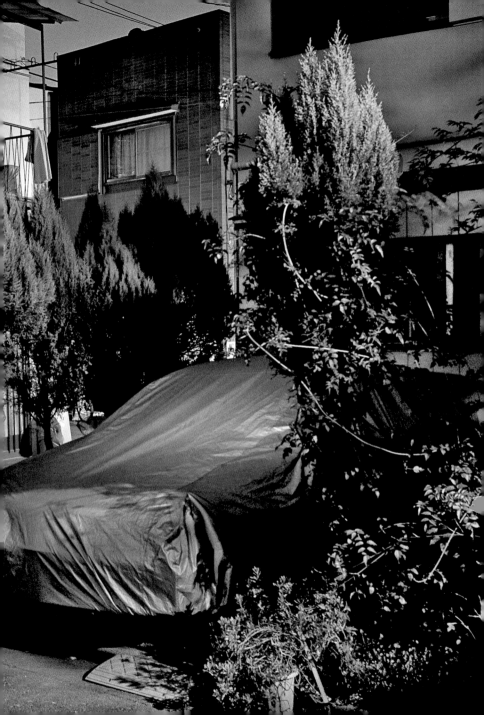

In an *onsen*, a steam bath in Tokyo.

this book was a response to an order from the United States' anxious Office of War Information, at the end of the World War II, to deliver a manual to its occupying forces. Its author, Ruth Benedict, had to write it under two major constraints: her ignorance of the Japanese language and an inability to visit Japan. Thus, it was from a distance, skimming American libraries, magazines, and exiles' testimonies, that she succeeded in writing—in only a year—what the Japanese consider to be one of the major books on their society.

The Japanese, writes Ruth Benedict, live first and foremost as heirs of the past. Their feeling of debt toward their masters in a broad sense (ancestors, parents, professors, and even the emperor) grows with time. Repaying one's debt becomes a question of dignity. Not succeeding to do so covers you in shame. Every person dedicates his life to reducing his debts and to avoiding imposing them on others. Thus, when faced with an accident, a crowd will remain passive for fear of inflicting a debt on the victims. This feeling of being indebted, so singular, entails duties. The first of all of them being not to soil your reputation: an obligation so strong that at the slightest misstep, it turns against you. People disappear or kill themselves before anything else out of politeness, as not to make someone else's life difficult. "The vulnerability of the Japanese to failures and slurs and rejections makes it

all too easy for them to harry themselves instead of others," writes Ruth Benedict.

At the time of the mass evaporations caused by the financial crisis and debts, the detectives were still quite young. This type of escape still exists, but people have also learned to seek legal proceedings to erase their debts. Unfortunately, new generations of helpless people are appearing. They are barely thirty and belong to the "lost generation." Entering the job market in the 1990s—the lost decade—these young adults can no longer even escape into their work, that excuse that consumes body and mind. Unemployed or forced to accept part-time work, they stare off at a dark horizon, unable to see any future. Their diplomas are no longer as valuable with the recession ahead of them. Many must live with their parents until marriage, unable to afford rent on their own. Some even live like this as a couple. Facing a precarious present and a dark future, the members of this Boomerang Generation are looking for a way out.

One of them, age twenty, had sent a brief note to his parents: "I'm doing well, don't worry." Starting from the location where the letter was sent, the sleuths put up missing person notices. They found the young man, after being gone ten years. He kept his name and works in a temp agency as team leader. He pays taxes in his new town, but has never

used his credit cards or social security. "The people who flee debt and violence change their names and sometimes their appearances. The others aren't necessarily thinking people will try to find them," explains Sakae. The runaway invited his parents to lunch, as if they had just seen each other yesterday. They did not recognize their son, seemingly happy, vibrant, and well integrated. They did not understand why he disappeared, and did not insist on finding out.

A detective from
the Galu agency in
Osaka. She investigates
adultery cases, disputes
between neighbors,
harassment. Then come
the disappearances.
A lot of the cases are
never solved.

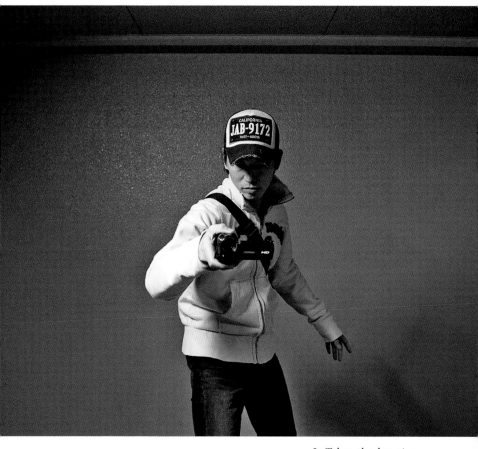

In Tokyo, the detective Hideki Harada subtly changes his look in order to trail people as discreetly as possible. He tracked down a young boy, declared missing, at the Tojinbo cliffs.

12

Ayae
Evaporated for twenty-one years

"My husband was a butcher. I would have been just as happy if he had been an undertaker. We lived in a wooden house, inherited from my parents, in a rural and hilly region where icy winters force you to withdraw inside. My husband, Eiki, would ride his bicycle down the calm streets to the oldest butchery in town. When the streets were icy, or it snowed, he left for work on foot, nose in his scarf, arms crossed, his steps uneasy like a penguin's.

"I can still see it, that butchery: neat and tidy, lit in neon. The boss, a punctilious type, demanded his two employees bend over backwards for their customers. They had to serve choice meat, cut with finesse and delicately wrapped. He had

a rank and a reputation to maintain. Gossip spreads like wildfire in that village of ours.

"Eiki would leave early in the morning to receive deliveries, then stay busy all day until closing. He had to go to the slaughterhouse regularly, to verify the quality of the orders. He never complained, but he didn't like his work. He hadn't chosen it. His older brother ran their father's small shop. He had taken what he could get.

"Things got busier when a competitor closed its doors. My husband came home from work with bags under his eyes, his hands worn, looking more and more downcast. He would go to bed without a word. Our son never saw his father. I was raising him alone. When he was at school, I took care of the house and the meals, I exercised a little, I read, I took drawing and pottery classes. I was bored.

"One April evening, just as the cherry blossoms were beginning to open, the head butcher, Hiroshi, invited us to dinner, my husband and me, in a Korean restaurant. The boss made it his duty to spend time with each of his employees. We had known each other since childhood, we went to school together. I really liked him. He was funny, with his precious manner and immaculate appearance, so contrary to his profession. Passionate about food, he gushed about the tenderness of veal, a ginger-flavored beef recipe, or grilled meat

with herbs. But he was the boss, and I didn't dare address him directly.

"Three days after the dinner, I was in the middle of tidying up the house when the doorbell rang. It was Hiroshi. I thought something serious had happened to my husband. But he reassured me: 'I was passing by and I said to myself, why not ring?' He was very emotional.

"He came back. From time to time, then more and more often. He would sit there on the futon. I would serve him tea and little cakes. We hardly spoke. Little by little, I got up the nerve to look at him. I liked his cologne and his old-fashioned suits.

"I remembered him, little, at school, sitting in the corner of the classroom, or alone in the schoolyard. The others weren't in a rush to play with him. Children are cruel; they say things that hurt for a long time, words that wound, bring you down, humiliate you. They made fun because he was a *burakumin*, the lowest caste in our town. You can't read that class difference on someone's face, but people know. The reputation gets passed down from generation to generation. I was a shy little girl, and I thought he should suffer like I was suffering.

"Our private meetings continued into autumn, the most beautiful moments of my life. We never touched each other.

We would look at each other, and that was already a lot. And then, on the morning of October 16, Hiroshi came in, sat down, and blurted out without stopping, almost without breathing, his tongue burned by the tea, words I will never forget, one by one: 'I love you, Ayae. I have always loved you, but I never dared tell you. You were so beautiful. I was the son of a butcher . . . I hired your husband to be closer to you.'

"I was speechless. He ultimately got up and left. I felt like I was sleepwalking, my brain foggy. I arrived late to pick up my son, I broke a pile of dishes. In the following days, I felt detached from my life. Did I love my husband, chosen for me by my parents? Memories from our wedding night came flooding in. A feeling of disgust. Eventually, I had just grown accustomed to him.

"And he, Hiroshi, my childhood love, a fine, funny man. I dreamed of seeing him again, but I was paralyzed, trapped in a hellish cage. I was afraid of going outside, of running into him. At home, I dreaded the day he would come back. Our relationship was impossible in such a small town. My husband would clearly have found out. He would have been capable of the worst. I felt guilty, I stared at the clouds for hours, I stopped taking care of myself, I no longer felt like doing anything.

"My son was at school. I was in charge of my husband's finances. I took all of our savings. I left without locking the

door behind me. Abandoning your son: is there anything worse than that? I did it.

"I knew where I was going. I had a meticulous plan. Withdraw cash. Take the train. Hide myself under a hat. Leave and start from scratch. Be ready for anything . . .

"I ended up in a cheap hotel in Tokyo, surrounded by bright towers, shopping centers, and arcades. I stayed holed up in a simple room, no larger than a futon. I thought about my son, about his joy and overflowing energy, my son who could find anything fun, surprising, moving, who was passionate about everything, driven by mischief and hunger.

"I thought about nature, the fluffy clouds, the forest just outside our door back home: magical walks under the trees, games on the moss with that little man I bore . . . I asked myself, what had I missed? What was I going to miss?

"The only times I left my room were in the evenings to slip naked into the ladies' bath. The heat and steam reassured me. I was shedding my skin, becoming another person, without ties, without crutches. At the end of a week, I put on high heels and my most beautiful, close-fitting dress made of light silk.

"I passed by banks that loomed like temples, crowded and noisy stores, intersections swarming with people. It was my first time seeing Tokyo. A whole world separates my town and the capital. I finally found the address and hurried onto the

elevator of a huge building, taking it up to a chain restaurant. A woman in makeup with a plunging neckline was waiting for me. She was a childhood classmate who had married a violent man. After her marriage crumbled, she fell out with her family. Back up north, they said she earned a lot of money in Tokyo. What are they saying about me in the village?

"The dinner was pleasant; Chiyo, warm and frank: 'The life of a single woman with no money is hard. At thirty-five, you aren't as desirable. But you are still fresh.' Between two cigarettes, she jotted a number down on a corner of the tablecloth. 'Go tell him I sent you, he will have work for you in Kabukicho.' In a big neighborhood the size of five or six football fields, Kabukicho attracts all types of sexual desire. The bright signs display tantalizing smiles and pleated skirts raised up over the thigh.

"Other signs show the faces of tanned boys with spiky hair. They are the 'hosts,' confidants for a night, who offer ladies their company for a drink, or more if they desire. Passing by the bouncers in black suits standing at the entrance to the establishments, Chiyo whispers to me, 'You'll see, if you take the job nothing will happen to you, the yakuza will protect you.' I was uncomfortable. It was nighttime, and I was cold.

"Chiyo's contact offered me a meeting in a neighborhood bar. Someone led me between the empty seats and

the lapdance bars up to a seated man, accompanied by two guards. I approached sheepishly. He had a chubby face, frail shoulders, a black suit, and was sipping juice through a straw. At first glance, he looked like any other working father, but he was missing a knuckle on his little finger.

"I understood his two propositions right away. The first was to hire me as a hostess: I'd have to, he briefly explained, entertain the client, encourage him to open up, seduce him until he wants to go further for more money in a side room. Or the other option, for less pay: be a waitress in one of the establishments. Salary in cash, no contract, and no mentioning the job outside.

"I chose waitress. I made a new life for myself in a short skirt and stiletto heels. I worked hard, every night. The rest of the time, I slept. Chiyo remained my only friend.

"After a few years, the mafia entrusted me to run a tiny night bar. A funny place, that bar. Teeny, long, and narrow, covered in old-fashioned paneling, it could seat no more than five customers at a time. I knew them all. They would come and go according to the whims of life and fate. Bankers, doctors, artists, salarymen, the powerful and the lost, married men and eternal loners. I filled their glasses, I listened to their troubles, I drank and smoked with them. The more I listened to them, the more they drank.

"That bar was my home.

"Among the regulars was a married businessman, father of two. He always arrived at nightfall, pairing drinks with compliments. He became my lover, a passionate, devoted lover. We saw each other for ten years on the sly. Ever since he retired, his wife has kept an eye on him, so I don't see him anymore. He never made me promises, but thanks to him, a few years ago I was able to open a small grocery near here. A grocery, my grocery, do you realize? If my parents only knew. It wasn't what one envisioned for a woman like me.

"I was always evasive with him. I was afraid he would discover where I came from. But he was an intelligent person, and he guessed that I was a worthless girl, a *burakumin*. We are destined for a cursed life.

"I left an impossible love. I fled a label. I wanted to get some air, take my chances far from the smells of raw meat and the neighbors' contemptuous looks. I saw miserable women sell their bodies, poor guys lose themselves in booze, and the mafia getting rich off this helplessness. I was a weak link in the business.

"I fell many times. I picked myself back up.

"It took me fifteen years to gather my courage and call home, to my house in the north. On the other end of the line, a stranger explained that the former owners lived in Kobe and gave me their contact information.

"It took me another week to dare dial the number. A deep voice answered the phone: 'I knew you would call, Mom.' I hadn't recognized my son. He was a man now. A man!

"He had studied law and worked as a lawyer in an import-export business. Yes, he was doing well. He would come visit me one weekend as soon as he had the time, he said. I would have liked him to run to meet me. I waited.

"We met each other in a café, like two strangers, and he walked me to my place, preferring to stay outside. He is now a handsome young man with a determined look in his eye. He told me that his father made him believe for a long time that I had been traveling. Then tragedy struck: the boss of the butchery killed himself. In his will, he bequeathed his business to his oldest employee—my husband—and to me. My ex-husband put all of his money away to pay for his only son's education.

"He died last winter. A car mowed him down.

"My son told me, 'I was alone in the world. I needed you. I was angry at you.' He didn't talk much; it was too late. He will never forgive me."

Pleasure district of
Kabukicho, in Tokyo.

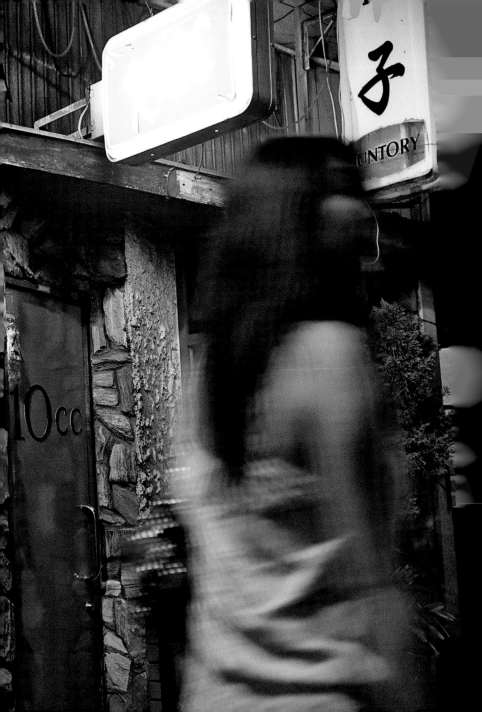

13

They appear suddenly in spring and disappear just as quickly. White, pink, pale, or dark, they bloom all along the avenues and transform the ugliest square into the Garden of Eden. During World War II, the Japanese government made people believe that the souls of soldiers killed in combat would be reincarnated as cherry blossoms. Did the myth endure after the war? As they wander, are the evaporated attracted to these symbols of a beautiful and ephemeral life?

The detectives do not rule out any lead. This afternoon, Takumi, the sleuth with the handsome and serious face, crosses parks, eyes peeled, looking for these living kamikazes. In a Zen garden decorated with cherry blossoms in bloom, camphor trees, bamboo, and persimmon trees, old people walk very slowly, almost not moving at all; salarymen empty their bento, partitioned wooden boxes filled with rice, fish, and colorful vegetables. Later, Takumi will visit several cyber cafes where, like a regular customer, he will disappear into a discreet cubicle, convenient for taking a break or looking at a pornographic website. Then he will show the manager

a photo from his bag, and the manager, without even deigning to glance at it, will shake his head—no. His customers are free, and he does not want to know anything about their lives, nor give away any of the place's secrets. Takumi will thank him as usual without getting discouraged.

Next he will enter the lobby of a "capsule hotel," a uniform establishment made up of cubicles stacked one on top of the other. There, the guests leave personal items and their identities in lockers before donning regulation pajamas and lying down in small, long, and narrow spaces shaped like coffins. Another anonymous and transitory place where a runaway can make a pit stop on his way to becoming someone else. Featured on the small poster Takumi is carrying around today is a retired elementary school teacher who disappeared a few weeks earlier from Tokoroza, not far from Tokyo. Married, father of two self-sufficient children, he seemed to have a peaceful life. Everything was going well. The family always says the same things. When Takumi met with the wife, he gently, tactfully asked her if anything could have disrupted this peaceful life. So she described her husband's addiction to a television show about mechanisms for financial investing. Immediately afterward, he began dabbling in the stock market, sure of the successes to come. He had a lot of self-confidence and strong convictions. "I always had to go along with what he wanted," she told the detective. And as

she feared, he lost—a lot. At first, she reassured him on the grounds that their savings could guarantee them a comfortable retirement. But the man was mortified. One morning, when she got home from shopping, she discovered a note on the kitchen table: "I might have gone overboard. I'd like to live alone now. If I fail, maybe I'll come back. If I return, please take me back."

She searched the house. He had taken his driver's license, a travel bag, and his school bag. But he had left his credit, travel, and medical cards, and all of his clothes. The detective tells the story: "First, she contacted the police, who didn't do much after seeing the note, then she came to see us a few weeks ago." Upon examining the missing man's Internet history, he discovered that the teacher had checked, several times, the train schedule for Nikko, one of his favorite cities and a regular destination for class trips with his students. The investigation led him next to the computer club for which the teacher maintained records. The day before his grand departure, he had taken care to put everything in order. Likewise, he had turned down the invitation to his grandson's piano recital, claiming, a bit vaguely, that he wouldn't be available that day. This was enough evidence for a premeditated disappearance, according to the detective, who then decided to go to Nikko, the city from the class trips. Unsuccessfully.

His search now leads him to Ueno, Tokyo's central station, where he paces back and forth in front of the

train platforms. All around, the shop signs sparkle and the halls abound with commuters, briefcases under their arms, men in a hurry and compressed by the crowd. How do you find someone in this human sea? Locked behind closed doors, this impenetrable culture is exhausting me, but Stéphane is taken with the frantic investigation.

Takumi swoops in on a station master, then on a nearby police officer. A glance at the photo, a shake of the head. The detective explains his method: "I'm betting on my luck." Walking briskly, he explains that running away, sometimes, is temporary and that the evaporated can reappear. There is no rule or standard. A runaway can show up at a funeral and disappear again just as abruptly. He can also call his loved ones, just to give a sign of life. Others are found outside their children's schools. Or simply sitting on their front steps. Those who return do not always get a warm welcome. The spouse has moved on, remarried. The children think they are losers, cowards.

The detective tells us about an investigation resolved in an unexpected finale. A forty-year-old man had disappeared, leaving his identification in his car parked in the lot of a town hall. Threatened after having appealed to an illegal loan company, he ran away and was in hiding until the detectives of the organization finally tracked him down. The detectives offered

to tell the man's mother his location. But the woman declined the offer. Knowing he was alive was enough for her.

According to Takumi, the reunions are rarely happy. "Close relatives think running from society is the wrong choice. In our country, failure is unacceptable. It means that the individual has not honored his mission, his role in society." One day, a woman asked him to find her husband, who had disappeared at thirty-five. Driven to unemployment, he was taking an expert-accountant training course in Saitama. On the eve of his disappearance, the couple had argued violently, the wife showering harsh words on her husband. She was expecting him to return quickly, but after he had been gone three months she began to fear a suicide. Takumi found the husband in an apartment rented by the week, with no security deposit. The man, passionate about football, had traveled around the country from city to city and match to match, paying for everything in cash. Their relationship, now restored but tenuous, threatens to implode. "Things in the past are like a plate that's shattered to pieces. You can never put it back together like it was," writes Haruki Murakami in *Kafka on the Shore*.

In front of the train station, in a square full of suits and pleated skirts, the detective mentions another young man, whose possessions were found on a ferry to Kyushu. He gives me the family's telephone number. "*They* will talk to you."

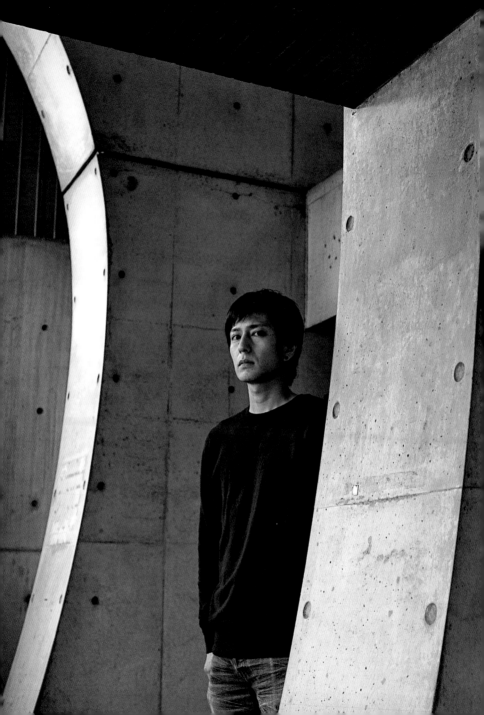

The detective Takumi Hayashizaki, from the Association for the Support of Families of Missing People, spends his free time investigating disappearances at no cost.

A "capsule hotel," near Tokyo's Ueno Station: this type of establishment, inexpensive and transitory, can serve as a safe haven for runaways.

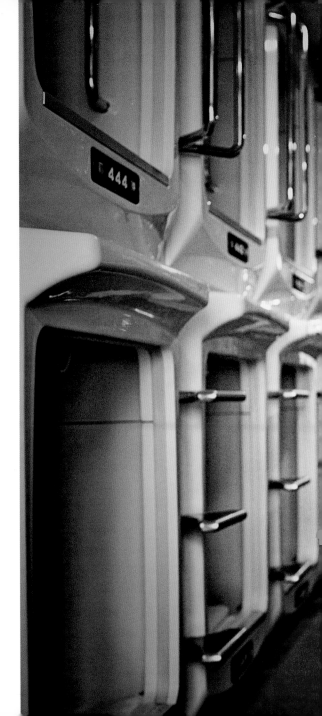

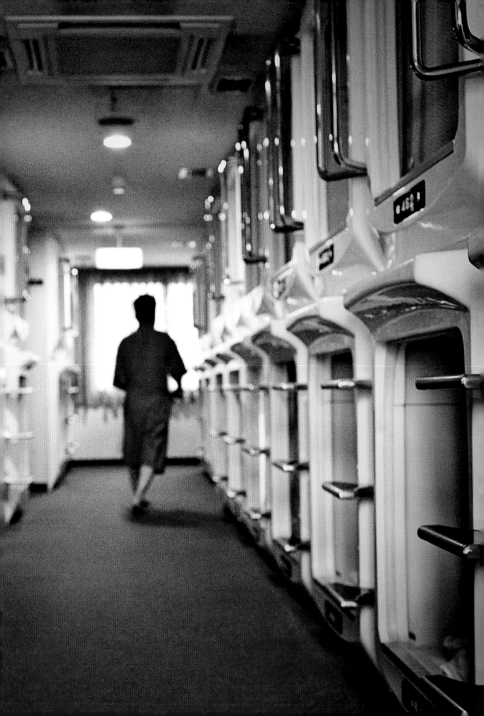

14

Every evening at 6:56, a ferry leaves the pier for Kyushu, the southernmost of the archipelago's four big islands. Tsuyoshi Miyamoto arranged to meet me in the exact place where his brother boarded a ferry that would lead him off into the unknown. The terminal is located at the tip of an artificial peninsula grafted to Tokyo Bay. To get there from the elevated metro, you have to weave your way through a rusted landscape—abandoned vehicle frames, containers, cranes. Under low clouds, thirty-five-ton trucks filled with merchandise whiz past us. Across the water, Odaiba island, a futuristic display, showcases Tokyo Big Sight, a high-rise turned zenith of Tokyo's cultural life. This vast agglomeration of art galleries, conference rooms, and movie theaters borders an amusement park, its Ferris wheel, and beaches.

On the horizon, the freighters, smoking steel giants, remind us that the archipelago is made up of over six thousand islands, a confetti-like geography that is positively confusing to foreigners. They generally only visit Honshu, the main island,

as big as Romania, which is home to the most famous cities—Tokyo, Kyoto, Osaka, Hiroshima—and intoxicates them with both the exotic and the modern.

Our contact lets Jun know he is running late. Tsuyoshi Miyamoto, coordinator at a night school company, is just leaving work. We walk back up the inhospitable quays where truck drivers are the last passengers to climb aboard the white ferry. Before long, its lights vanish into the fog, and the night swallows the waves. Off in the distance, we see Tsuyoshi running toward us. His tie, flapping in the wind, whips him in the face. He sits by the water and, as the ferry's siren rings out, turns to look out over the dark horizon. He is no longer part of the journey. What is there left for him to find? There, on the quay he has paced a hundred times, he keeps rehashing the same questions.

Naori Miyamoto, his younger brother, disappeared on May 3, 2002, around 3:00 p.m. At least that was when he slammed the door of his parents' apartment, shouting that he would not be eating dinner with them. His family did not see him again for the next two days but did not really worry, knowing him to be both a night owl and an adventure seeker. Had he not already traveled alone around Pakistan, India, Hawaii, Australia, and other exotic countries, a pretty uncommon path for a twenty-four-year-old Japanese man?

A call from the Ocean Tokyu Ferry company was all it took to send the Miyamotos into a panic. On the other end of the line, an employee informed them that the staff had found their son's bag, his wallet, and 24,000 yen ($200) while cleaning the cabins at the ferry's terminus on Kyushu island. His parents' contact information was included in his identification. The employee wanted to know how to return his things. The mother hung up, trembling, and called her stunned husband. Why had Naori taken this trip? Why would he have left his luggage behind? He had never mentioned a visit to Kyushu, an island where he did not even know anyone.

Tsuyoshi and his mother took the boat to go collect all of Naori's effects from a desolate storage room. A bag carried the essentials: wallet, keys, warm clothes, camera, and contact lenses, but also opened packets of cookies and a bottle of fruit juice. The ferry staff tried to piece together the mysterious journey. It was beautiful out that day, but few people had boarded. The shape of the ship, with its exterior terraced walkways, made any suicide nearly impossible. The employees maintained that Naori could not have jumped. So had the young man made a stopover at Shikoku perhaps? Or had he covered his tracks by putting his things on the boat but never leaving the port of Tokyo? Baffled, the crew members could not provide another explanation. The police

refused to take fingerprints since there was no evidence of a crime. Since the Miyamotos could not afford to hire a private detective, Naori's brother led the investigation himself. He has already interrogated bus and taxi drivers, but not one of them remembered a young man with an athletic build. The ferry also transported vehicles—had Naori been pushed into a car by strangers?

After leaving the port, Tsuyoshi leads us to his parents' apartment located near the Tabata metro station, on the thirteenth floor of a building illuminated by the lights of exterior staircases. The couple invites us into their sitting room, where we gather around a coffee table covered in steaming dishes, soups, rice, fish, vegetable tempura, chopsticks, hot tea. The mother, Harumi, a woman with a round face and clear glasses, softly explains that she ordered everything at the delicatessen for fear we would not like anything. The father, Masaei, his features tired and cheeks sunken, sits down in a little chair to leave us the couch. Everything, from his frail body to his sad mouth, gives away his suffering. They each thank us and apologize profusely for the size of their apartment, revealing their embarrassment at being simple people, those who are never seen or heard.

A missing person poster hangs conspicuously on the wall, illustrated with a photo that could have been ripped

with no explanation. The issue still poisons the relationship between the two countries. The Miyamotos meet me in the hall, smiling, as if relieved at having done their duty.

The father will go to the town hall afterward to check, as he does every quarter, if his son might have gone to update his residence certificate. The Miyamotos obtained a court's authorization to open a special account in Naori's name, into which a part of his father's pension is deposited every month. He sighs. "The years pass. We are getting old. We need to find a resolution to this story. It's even harder for his brother, who will have to live with it a lot longer than we will." Naori's mother adds, "We simply want to hear from him, he doesn't have to come home. If he needs money, we'll send it to him."

On this quay of Tokyo Bay, Tsuyoshi Miyamoto's brother boarded a ferry and never came back. The boy disappeared on May 3, 2002, at the age of twenty-four.

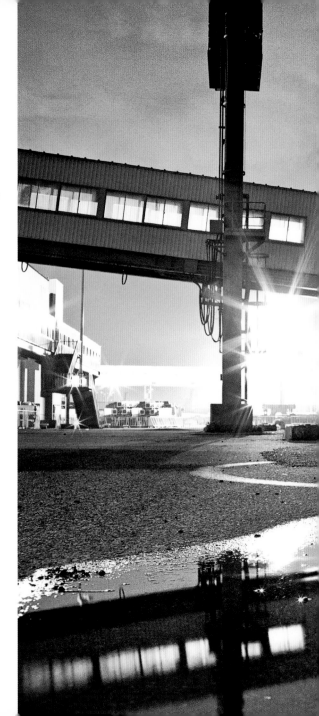

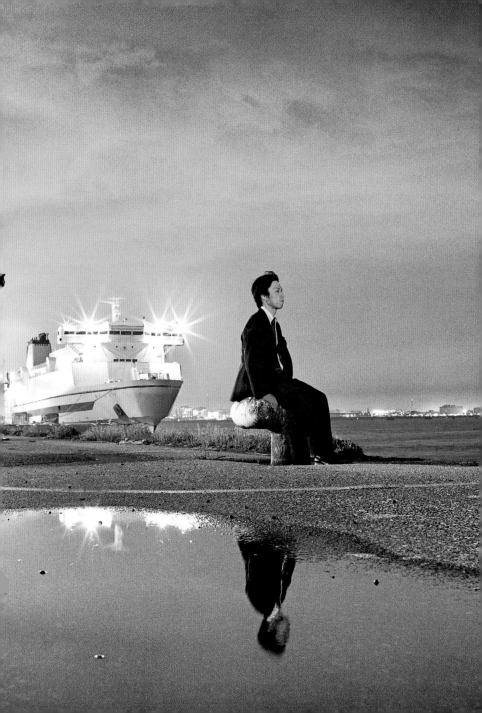

The employees of the ferry company found Naori Miyamoto's things on board, a bag containing the essentials: wallet, keys, warm clothes, camera, contact lenses, open packets of cookies, and a bottle of fruit juice. His parents printed and posted missing person posters, to no avail.

After the disappearance of his son, the father, Masaei, took sedatives for a long time, plagued by insomnia. He regularly sends messages on a radio that broadcasts at low frequencies in North Korea.

The Japanese government has recognized the kidnapping of seventeen citizens by Kim Jong-il's North Korean dictatorship over the course of the 1970s and 1980s. The families of the missing estimate there are several thousand. They meet every year at the convention hall to challenge the politicians.

15

The car speeds along the pavement in the pouring rain. Focused on the wheel, Jun drives toward what was once a source of national pride, the cradle of a world-renowned management model, Toyota City. Since 2008, this jewel of Japan has been sinking in the recession. Locals are fleeing the glorious city, they say. They are the new evaporated people of the financial crisis.

Jun did not find many contacts there. "It sure seems like the people of Toyota are scared," he apologizes. He is counting on the connections of a brave individual, one of the rare rebellious types in Toyota City. We call him from the parking lot of his eight-story apartment building, and he comes out to meet us. His smile is radiant, his salt-and-pepper hair perfectly combed. Tadao Wakatsuki gave his life to Toyota, and this morning, the first of his retirement, he is tasting a whole new freedom. Another life is beginning outside the company. He says this without expressing any particular joy.

From behind the windows of his car—a Toyota, of course—the streets roll past monotonously, devoid of people: new cars, lines of mechanical boxes, humming all around. And, repeated ad infinitum, the same old tune: "Toyota School," "Toyota Autobody," "Toyota Post Office," "Toyota Hospital Road"... Company, city, and landscape, Toyota constitutes a rational union. "The public transportation was intentionally underdeveloped. It's hell without a car here," Tadao remarks in passing.

His old factory, a gigantic citadel surrounded by thick fir trees, perches on high ground. Tadao spent forty-five years in the car-pressing workshop, his whole life's work. He walks up to the entryway, approaches the cameras and guardhouse, looks to his left, to his right, making sure we are alone. Then, suddenly, he performs a move, a perfect ninety-degree quarter turn, precise and fast. "That's how you have to move in the factories. It's one of the rules of the 'Toyota Code.'"

Followed by everyone, the Code governs the life of all the company's employees with an array of demands. Keep your hands out of your pockets; write a report on the risks of traveling between home and work—or home and vacation; leave your cell phone on all night; request permission from a superior to use the restroom; wait until you have been replaced at your post to go wash your hands; spend time at home thinking about how to improve the team's output . . . "On my

landed in Tokyo than some men pinned colored ribbons to his jacket and took him by train to the automobile mecca.

The next day, he had to join the ranks in front of the dormitories. He was given a locker combination, safety shoes, and a mask. Then on to the factory. In a few hours, Freddy, a mechanic in Peru, found himself working as a welder in Toyota City, confined, like the other immigrants, to labor under conditions known as the "three Ks": *kitanai, kitsui, kiken* (dirty, difficult, dangerous). Even without understanding a single word of the language, he still felt better than in the muddy suburbs of Lima. Back there in the sun, Freddy would never have been able to "afford a car. Not even in my dreams."

Happy to find an attentive listener, Freddy wants to take us everywhere, from his simple apartment where his daughter watches TV, to the Toyota Museum, to the Peruvian restaurant that serves pisco sours, a cocktail made with egg whites. He says, dispassionately, "We have to make a good product as fast as possible and with fewer and fewer men. Some can't stand it: they leave. Others go crazy, get sick, or kill themselves. You could say it's unfair, but that's how it is everywhere, isn't it?" In light of the financial crisis, the government is offering Japanese Latin American residents "aid for repatriation." Freddy does not want it. He is waiting. "The economy will pick up again one day, won't it?"

A call from a Tokyo journalist gets us a meeting with a pretty reckless young engineer to give us a tour of the company's living quarters, which some employees have fled. A rendezvous is set in a square near a fountain. Tall, slim, and elegant in his suit, the twenty-five-year-old engineer shakes our hands, quickens his pace, enters a Chinese restaurant, and sits down at an isolated table. He works at the headquarters, in the glass tower, and does not want to be seen with Westerners. "When I finished my studies, I fell in love with Toyota's prestige. There is nothing better to put on your resumé." For months, Toyota trained him, taught him their rules, their values, and their well-ordered convictions. "A true brainwashing."

The engineer lives in one of the long, low, gray dormitories. In the pitch-black night, with an air of detachment, he drives past the guardhouse, climbs the steps of the exterior staircase and, his hand shaking, opens a door equipped with a little lamp. Inside, he catches his breath. "Toyota houses us, educates us, tells us how to behave, as if we were children."

The tiny bare-walled room contains a bed, a messy desk, a shelf with a row of the company's bibles (*The Toyota Miracle, The Toyota Management, The Toyota System* . . .), a mini-fridge, a sink, and a suit jacket. "Toyota only provides the bare minimum. As if they value machines more than people."

As soon as he gets a day off, the engineer escapes from his employer's "grasp" to run off to concerts and lively restaurants in Tokyo. Little pleasures unimaginable in this charmless city. A promising executive, he is planning to quit as soon as the economy bounces back. Yes, others have run away. Without a word to their families. He has heard about it, but that is all he knows.

On the conveyer belt of a sushi bar, little dishes of raw fish parade by like parts on an assembly line. Tadao Wakatsuki, the rebellious retiree, serves himself cuttlefish and sashimi. Even if no member of his union dares speak up, *he* is no longer afraid. "Toyota invented suffering at work. Denouncing the abuses of that philosophy is one of the principles that guided my life. And I didn't give in, despite the numerous pressures." He fights for the unhappy, those driven crazy by the infernal clanking of the factory assembly lines. For those who are killing themselves from overwork. From fatigue or hopelessness. He says that Toyotism kills in Japan, certainly, but also in France, in all of the companies that drive home the idea that a good employee must devote himself to his boss, who in turn can discard him like a Kleenex. "Those who imitate us are mistaken." He is confident. The other day, for the first time, an employee dared to take one of his pamphlets in front of the factory.

A temp at Toyota, unemployed since 2008, wants to reassure himself: "The economy will pick up again one day, won't it?"

I turn back. I can't, that's all. It's too late. I hurt them. I can't take it back.

"When I arrive in Tokyo, I settle in Sanya. I'm a bike messenger, sweeper, mover, cashier, waiter, backroom electronics repairer . . . I had loads of jobs, some very bad, but I never left the neighborhood. You get over the bad smell. At first, when I was in my room, I had to breathe into a scarf. I kept it on my face all night. I don't sleep well. I haven't slept well since I left. It must be thirty years now. It's been a nightmare.

"There're tons of guys like me in Tokyo. There're some who collect bottles and lost objects, too. I spend time with an amazing guy. He sleeps in the park; he built a hut. I think he's a security guard, but I see him selling newspapers. He likes to be called Gaara, 'he who only likes himself.' In reality, he likes people, believe me. He gives nicknames to people he runs into at the bar and pays for their rounds of sake; when he finds a nice pin, he gives it to me. He must have died by now.

"Oh, and Asataro, do you know him? He worked on construction sites. He never talks about his past. All I know is that he had a little dog with long fur. I would have liked to have had a dog. These days, Asataro drags his leg, an accident, I think. I've seen a lot of broken lives. We recognize each other by our broken lives. No one asks for our identification. It works out well for people that we exist."

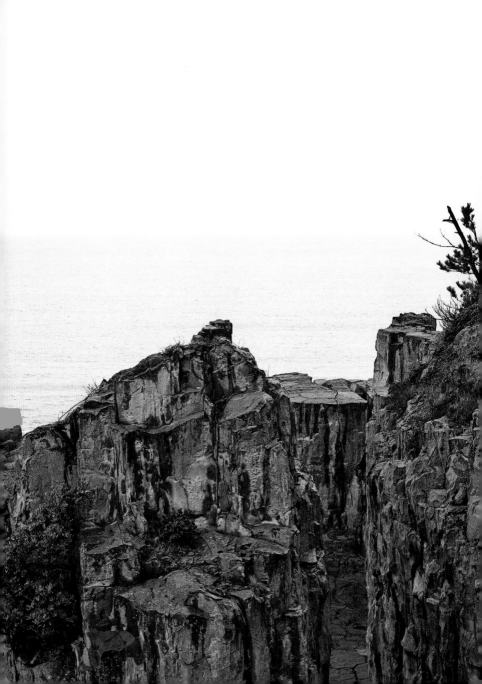

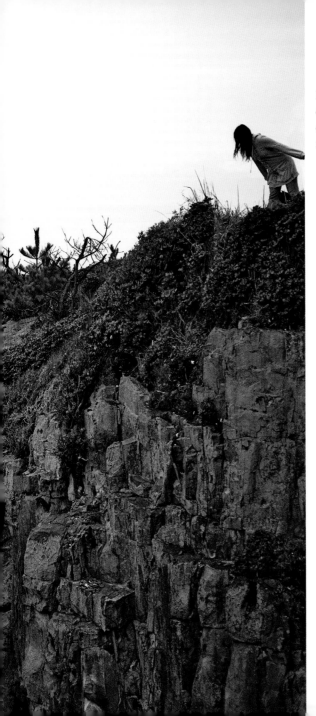

Buses full of tourists come to the Tojinbo cliffs, famous for their record suicide rates.

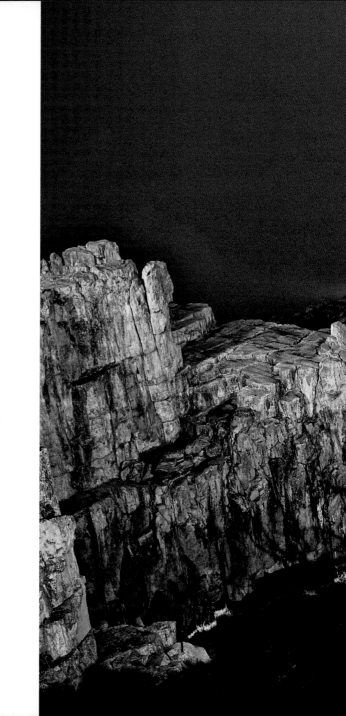

mission to dissuade desperate people from ending it all in the waves. He concentrates all of his time and energy on it. We accepted Mr. Shige's invitation and traveled two hours from Tokyo City to visit the jagged cliffs, as magnetic for the evaporated as the hot springs or the dense forests elsewhere. He does not know how far back this dark attraction to natural places dates. But he is sure that writers such as Jun Takami, Kyoshi Takahama, and Toyoko Yamasaki glorified it. And that reports on television sustain it.

Mr. Shige recognizes the desperate by their dark clothes, by the lack of a bag or camera. "I approach them gently and whisper, 'How are you?' They blush or burst into tears. Often, that's all they're waiting for, a word, a gesture." The former policeman walks back up the path, and, at the entrance to the bus parking lot, points out a shop. "I invite them here." A simple store at first glance. But inside, a whole world is bustling: a hot stove, the smell of tea, heaps of oilskins, boots, and paperwork; comfort, whispers, tears, confidences; the comings and goings of volunteers, former police officers, Buddhist monks, psychology students, survivors hanging on to this place like a life preserver . . .

"My organization saved 248 people from suicide in seven years," says Mr. Shige, pulling up some chairs. A small, thin man, his arm in a sling, hurries to serve hot tea and the house

specialty, rice cakes covered in horseradish. Mr. Shige invites him to the table. "Haruki was alone on the cliff, walking hesitantly, when I went up to him." The little man agrees: "It had been a long time since someone spoke to me with such kindness. My whole life, I dreamed of only one thing: making money. I was married, I had a kid, but I abandoned them, selfishly."

A taxi driver in Tokyo, at sixty-five, he lost the use of his arm, paralyzed after an accident. Overnight, he found himself without a job or support. After trying and failing to hang himself because he had not tied the knot tight enough, he thought that he could disappear more easily in Tojinbo. "At last, I'm beginning to understand what it means to help others. I crisscross the cliff, I make rice cakes," says the man, now a volunteer, dressed in the same checkered shirt as Mr. Shige.

The policeman relights a cigarette and grabs a pile of documents from a shelf. "I write down every case of suicide in here. I also collect official statements and debates on this social problem." He has formulated his own opinion: according to him, the social hopelessness, the suicides, and the evaporations all share the same cause. He speaks of the malaise of his people, shaped by ideals of performance, contrition, and self-abnegation, destitute in the wake of a relentless crisis. He blames the profiteers, the mafia, loan sharks, and bosses who abuse their power and people's misery. And attacks all

the fatalists: "We have to stop hiding behind our traditions of evaporation, of the samurais' seppuku . . . If people are choosing to disappear, it's first and foremost because something isn't working and no one is doing anything about it."

A wall extends behind him, covered in articles written in every language. To the journalists from around the world who come to meet the angel of the cliffs, he tells the story of how his fight began. In 2003, while he was still a policeman not far from here, he received a suicide note from an elderly couple he thought he had convinced, five days earlier, not to take their lives. At the time, he had directed the little old couple toward other services. But, referred from counter to counter, the old couple ultimately hanged themselves. Indignant, Mr. Shige decided to publish, for the first time, the police statistics on suicide. Determined, he retired the following year and invested 3 million yen ($25,000) of his personal funds to set up his organization. In doing this, he was hoping to fill an institutional void.

While he continues to wait for public funding, Tojinbo's guardian runs his shop, keeping an eye on his finances. The sky has grown darker by the time he leads me out of the shop. A car parks and out climbs a young woman, thin, with smooth, lightened hair, denim short shorts, and a baby in her arm. "The child she almost jumped with," whispers Mr. Shige. He opens a little door adjacent to the shop, brings over chairs, and lights

the stove while the young woman takes a seat in the improvised visiting room. He assures her that her name will be changed.

Her eyes glued to her thin hands, fiddling nervously, the woman tells her story cautiously. She is thirty-three, has a husband, two kids. Six months earlier, she came to this spot with her youngest child while her husband was still at work. She took the coastal path and stopped at the top of a cliff. She stared down at the sea, thinking that she never learned how to swim and that the rough water must be very cold, when Shige came up from behind her, saying, "Wait a minute."

Would she have had the strength to jump that day? She kept the incident from her husband. She now visits the shop with her baby often, to find a bit of company, a conversation. She does not like her husband, was pushed to marry him by her family, but to leave him would be crazy. "I come from a really conservative world." At first she thought about running away. But where? To do what? With a glance out the half-open door, she notices it is dark out. She has to go home to make dinner.

Another woman comes in, generous, open, beautiful. Misako, former cook at Mr. Shige's police station, the first to have embraced his fight. The queen of rice cakes, that's her. The soft whispers in the shop, the tender atmosphere, that's her, too. In a land of modest indifference, of polite distance, she touches a hand, a shoulder, caresses a face, and reaches your heart.

On an April Sunday, Misako did something unprece-
dented by going with her mentor Shige to one of his many
conferences on suicide. Before an audience of 750 of the dis-
trict's residents—men, women, and children, including her
husband's family—she shared her story, holding nothing
back. A few minutes before the presentation, Mr. Shige got
nervous. "Are you sure? Do you really want to do this?" She
responded, "Did I do something wrong? Did my parents do
something wrong? I need to overcome the shame in order to
move forward."

Her father, a police officer and a violent man, used to hit
her mother when he got home from work. She and her sis-
ters would run and hide under the covers while her brother
called the neighbors for help. When she entered junior high,
her siblings left home, leaving her alone with her father's bru-
tality. One evening, exhausted by fear as he was attacking her,
she screamed that she wished he were dead. The next morn-
ing, she found him hanging from a belt in the garden shed.
Tragedy followed her when, a few months later, her mother
poisoned herself with pesticides. Misako was taken in by
relatives, and then began her studies, taking night classes in
Osaka. At twenty-three she got married, and the birth of her
first child made her painfully aware of her mother's absence.
But, of all her sorrows, the hardest to endure remains being the

daughter of suicide victims. "We, the children of the missing, dead or hidden somewhere, are pariahs. We are branded . . ."

Misako recounts an anecdote: as the wife of the eldest son, it is her responsibility to serve the tea during weddings and funerals. Yet her mother-in-law deprived her of this privilege, considering her unfit on the grounds that no one would have passed down the customs to her. She says, "It's a little thing, it can seem harmless, but I felt miserable. I went and took classes on good etiquette to learn how to perform the tea ceremony."

Misako met Mr. Shige in the cafeteria of the police station. He was writing a book of anonymous testimonies on suicide. For the first time, she allowed herself to tell her story. Shige could not believe it.

During our conversation, the cliff has become shrouded in darkness. Under his fisherman's hat, Mr. Shige sighs, taking a drag from his cigarette. Spring is returning. The weather will get milder, and the bright days of blue skies will inevitably attract new waves of the unhappy. The retiree shows a reassuring optimism, though. "I don't have a magic wand. I don't promise people happiness, but I tell them what people never say in this country: you can find a solution to your problem."

The next day, the tourists swarm in front of a sea bathed in light. Another survivor is smoking in the organization's

headquarters. He stares at us, his face emaciated, his body nervous and tense. Hideo Watanabe arrived undocumented in Tojinbo on the train on January 9, 2010. An engineer, he had been in a position of responsibility, won the recognition of his peers, and had a beautiful wedding. In 2005, his company went bankrupt, sending him into a terrible downward spiral. First temp work and then, one right after the other, divorce, betrayal, ruin . . . A few years earlier, he had cosigned for a friend hoping to start a company. Crushed by debt, his friend ended up evaporating. The banks ordered Hideo to pay for him, which he was quite incapable of doing. Alone, helpless, he considered throwing himself under a train. "But that would have disturbed the passengers." That is when he heard about the cliffs on television.

Mr. Shige's organization offered him a room. For months, pills calmed him down. Sometimes, he still has "urges to murder" his friend who disappeared. But Mr. Shige has something better to offer. Hope. Because Hideo can declare bankruptcy, his file will be examined, his debts probably erased. All legally. Hideo finally sees "a light" and decides to make a fresh start. He just found three small jobs. "It's a start." He adds, agitated, as if ready to fight, "If my friend disappeared, it's because he wasn't lucky enough to find a helping hand."

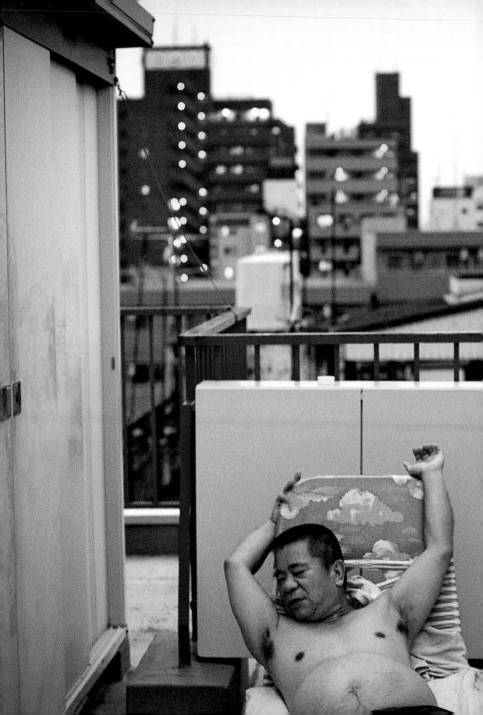

In Osaka, the Kamagasaki neighborhood, known as "Kama," is a haven for those divorced from their past, anonymous people on their last legs.

In the huge hangar of the day-labor market, vagabonds are among those outcast by outcasts, eaten away by loneliness, sometimes prisoners of their own madness.

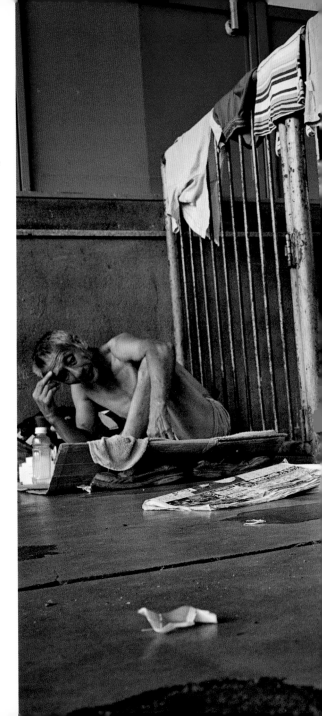

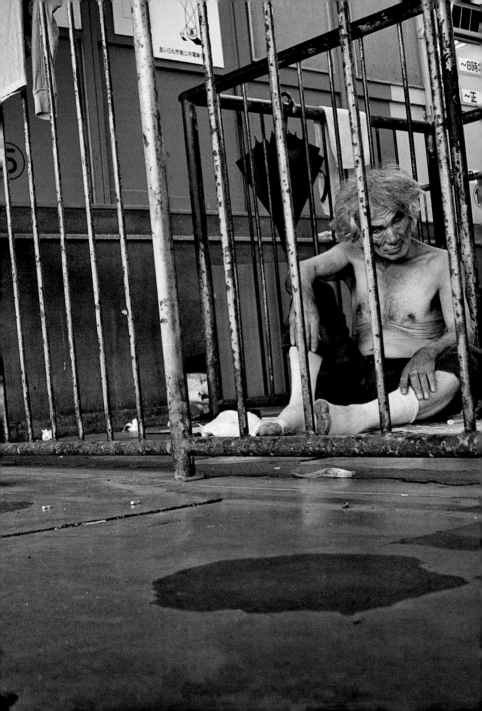

18

Slumped behind a counter taller than him, an over-whelmingly bored receptionist sleeps noisily, his mouth open. In the dining room, one hundred or so empty tables and their pristine napkins wait in vain for diners. Evidently, we are alone tonight in this monumental hotel on the edges of Tojinbo. I wander around the empty marble halls imagining employees from Tokyo gathered here on weekends for work retreats, watching boring PowerPoint presentations of which they will not retain much and getting drunk standing at the empty bar. Maybe during the summer these corridors, long and cold like airport concourses, hum with the murmurings of couples on vacation, surrounded by children going off to play at the beach, their little buckets in hand.

Jun's hurried step pulls us, the receptionist and me, from our daydreams. Our interpreter's drained expression reveals a night of bad dreams. Because last night Jun wanted to take off. Near the cliff, while Stéphane was photographing

Hideo Watanabe, the suicide survivor, the latter suddenly threw his phone violently against a wall, sent the tripod and the camera flashes flying, grabbed Jun by the collar, lifted him off the ground, screamed, and stormed off like a madman, leaving us all incredulous and shaken. I found our interpreter paralyzed, hiding in his locked car. He wanted to run away to Vietnam immediately, convinced the "lunatic" was going to come back to kill him. I barely managed to convince him to wait for Mr. Shige, who arrived a half hour later with some explanations.

Hideo Watanabe had felt "judged," "like a delinquent at the police station." Blinded by the "foreigners'" flashes, sitting on a chair with his arms at his sides, he had plunged back into the torments of his past. The anger, the shame, the old demons tamed by medication had suddenly overtaken him, making Jun his sacrificial victim. Mr. Shige asked for money to replace the broken phone. As for Jun, he did not want to be left alone; otherwise, he would leave. A strange evening followed, during which I played bodyguard to a panic-stricken interpreter while Stéphane, fascinated by the wild beauty of the cliffs, was on a quest for the perfect nighttime photo.

Jun gets back on the road with reassurance, but everything frightens him in our new destination. Osaka—the

country's third-largest city, industrial, commercial, bombarded during World War II—does not offer the effervescence of the capital or the refined magic of Kyoto, window into the Japanese soul. And all its highlights have been left off our itinerary: its gastronomy and its blowfish stews; its monumental palace, a national pride, burned, ravaged, and rebuilt many times; its nightlife along the canals; its dialect and the renowned warmth of its inhabitants, nicknamed the "southerners" of Japan.

There is only one neighborhood, on the south side of the city, that truly interests me. Kamagasaki, known as "Kama," is to Osaka what Sanya is to Tokyo: the haven for those divorced from their past, the anonymous on their last legs. Jun is well aware of its dark reputation. A storm rumbles in the cloudy sky when we finally get there. At the end of a railway underpass, a Dantesque vision materializes. A crouching man stares wild-eyed at a streetlight. Another, sitting with his back against the wall on a rusty chair, clears his throat and spits. A rusted bike squeaks as it goes by. Two figures follow, backs arched, carrying plastic bags. Despite appearances, Kama is not a shantytown or a den of thieves or even a slum. Save for a square filled with makeshift shelters, a television hanging from a post, and informal fire pits, the neighborhood, framed by train tracks,

is arranged in a row of small houses, surely less desirable than elsewhere but built to last; the litter outside indicates a failing sanitation department. Misery does not reside in the filth or in the ensuing stench, but really and truly in the hearts of the people. Their vacant stares, their skeletal, shriveled bodies exhausted by hopelessness reveal an unspeakable anguish.

These people who wander around us in the middle of the afternoon represent those outcast by outcasts, eaten away by loneliness, sometimes prisoners of madness, thrown to the bottom of the trash heap. The bravest among them, resourceful vagabonds, toil on construction sites that the financial crisis has yet to shut down. You have to get up before sunrise to see them pouring in, sleepy-eyed, with hands in the pockets of work pants, outside a gigantic, decrepit hangar. Just before five o'clock, the rusted gates come up and vans arrive, posting work assignments and wages on their windshields. Recruiters swiftly make selections by calling out the candidates' names, and a few hundred day laborers are quickly taken away in vehicles. In the 1970s, there would be thousands, sometimes up to ten thousand, of them. Built like Sanya on muddy ground stained by death and a dark history, Kama's enclave made up the most significant reserve

of temporary workers in the entire country, a barometer of Japan's economic vitality.

The living memory of this slave market is perched atop a slippery staircase covered in piss and alcohol. There, some of the unemployed sit slumped on the steps, with a flask of sake, in rags, with blank stares. The administrator of the temporary employment agency, upright behind his desk, talks about the time when this hangar provided labor for the reconstruction of Osaka, its airport, the 1970 World's Fair, and the city of Kobe, destroyed by an earthquake in 1995. But the subsequent oil crisis, followed by the bursting of the economic bubble and the impact of the subprime mortgage crisis in 2008, finally dried up the labor pool. Since then, the demoralized workers, miserable wretches lost and destitute, survive on this and that, collecting bottles and expired super-market food to resell.

In the next room, a poor soul sleeps slumped against the counter of a thin public official in charge of welfare. With glistening eyes, visibly touched by the fate of his clients, he maintains that poverty is gnawing at Japan like a starving animal devouring a carcass. His evidence: the dramatic increase in applicants for minimum income and in the number of beds in emergency housing.

Some of these men, their lives derailed, stop by the counter uncomfortable about seeking aid. The employee swears to do his best to respect their choice to lead anonymous lives. His team receives several calls a month from families in search of a relative. They often pop up when an inheritance is concerned, since a will cannot be executed if a missing person is listed as a beneficiary. Their contact information is written by hand on a big whiteboard so everyone can see. Reconnecting depends on the individual's desire, courage, and past. According to the administrator, 30 percent of the several thousand evaporated in Kama eventually drop a coin into a pay phone to reconnect with their families.

Jun tries to engage the people we meet in conversation, but his blatant unease only elicits vague pleasantries. Outside, the rain chills our bones. Luckily, a tavern beckons us. Humid, decorated by bulbless wall lamps, and deserted save for the boss hidden in the shadows behind a jumble of cups. Mrs. Kazumi has a melancholy face and wears a tight beige cardigan clasped with gold buttons. Due to the lack of patrons, she only opens her bistro for a few hours a day. It takes her so long to bring us three hot chocolates that we wonder if she has not gone to buy milk through a secret door. Nostalgic and candid, she describes how

Kama, her "city" for nearly forty years, has become an "open-air retirement home," a "ghetto for loners." "Even fifteen years ago it was bubbling with energy. Women were assaulted, yes. The yakuza settled their scores out in the open. It was violent and savage, but people worked, they drank, they lived . . ." Since then, Kama has lost its edge. Kama is bored.

The yakuza, pillars of the neighborhood, still hold everything together. They are easily spotted by their bodyguards (eyes peeled, cell phone glued to their ears, gold chains around their necks, not even trying to be discreet). Every time we pass one of them, Jun averts his eyes and whispers in English, "Another 8-9-3!" In Japanese, these three digits literally form the word *yakuza*. Originally, it had to do with losing at cards. As it happens, under a little awning set up on a street corner, three or four mafiosi are playing cards, probably the famous *Hanafuda*, made up of twelve sets of four floral cards depicting the months of the year. When, after the rain has subsided, we walk back past the yakuza and I pretend to go up to them, Jun anxiously raises his arms and pleads, "No, I'm not going."

At night, in a soup restaurant, our worn-out interpreter admits he can no longer stand confronting the ghostly face of the country. Even though he has distanced himself from his

country and its culture, the setbacks of his people affect him, and the fates of those we are tracking down reflect his own anxieties. Uprooted, without a family, Jun is afraid of ending up alone.

There is still one man left for us to meet, far from Kama, a few hundred kilometers from this underworld. Jun agrees to continue the journey to see the old man, who has been expecting us for a long time. Akira Takami has withdrawn into the middle of a forest of slender trees, in a wood cabin grayed by time and lashed by rain. Drawn out of his solitude, he welcomes us dressed in a big striped wool sweater and carpet slippers. Taciturn, with a shy demeanor, he leads us to a paneled living room cluttered with ten or so speakers and top-of-the-line hi-fi equipment, which he says he had ordered from Europe and the United States.

Akira introduces himself as the heir of a music-loving family: a pianist grandfather, an amateur musician father, and he, born in 1929, employed at a pharmaceutical laboratory by necessity but passionate about music, "in search of the most perfect sound possible." With a bright and childlike look in his eye, the old man is awakened and amazed by Beethoven and Mozart's sonatas; his exhilaration is contagious. Only music calms and soothes his days since the death of his wife and the disappearance of his son.

He has been alone since then; this is what gives his life meaning. Akira takes his time praising the magic of opera, his physical, visceral, and absolute connection to classical music composition. We imagine he is delaying the moment when, his eyes misty behind his wire-rimmed glasses, he will have to bring up his son, evaporated at forty-four, one autumn day, October 6, 2003. As he arrives at this point of despair, his mouth sinks into a frown.

Trained in industrial design, his son Toru began his career designing bikes, then entered a civil service department of the Osaka prefecture. A good position paired with job security. There, for months, investing large amounts of his personal time and giving no thought to relationships, he designed an important urban redevelopment project aimed at helping the handicapped access public places. The father, who seems proud of this career path, sighs. "I was never very close with my son, since I dedicated my life to my work. But at the time, his mother had already passed away, and he called to tell me he was having problems with his company and his managers. He was working under a lot of pressure, like a dog. And in the end, his project had not been accepted by the management . . ."

On a Monday, around 11 o'clock, Akira received a call. Toru's boss.

"Your son isn't in the office this morning. Do you live far? It would be a good idea to go visit his apartment . . ."

"From his tone, he was clearly thinking suicide." Since the father did not have a set of keys, the company had the police enter their employee's apartment. Everything was in its place, only the company laptop was missing. Toru had even left behind his wallet and contact lenses. Meaning he had taken his glasses, which he did not ordinarily wear in public.

For two years, Akira looked for his son all over the place. At Toru's office, he questioned his son's colleagues, who described a "calm man" who "avoided friction." He made his own missing person flyers with Toru's photo, height, and weight. "But people told me the more I looked for him, the less likely his return would be, so I let it go. Maybe he went abroad." Akira slides a door open and from an adjoining room, plunged in darkness, he brings back a cardboard box. Kneeling on the carpet, the eighty-year-old man delicately pulls out, like relics, his son's black leather datebook, his binder, his diary lacking any warning signs of a disappearance. He takes his time leafing through it for several minutes. "I'm still paying off his apartment. But I'm going to have to stop. I need to put some money away to support me if I get sick." Akira does not cry. Faced with his

impassiveness, I realize that here, in Japan, I have not seen one tear fall, neither on the unfathomable faces of the runaways, nor on those of their loved ones. The old man closes the box and adds, wearily, "I think it's time to declare him dead." In this icy living room, in the middle of the woods, the speakers play Vivaldi's *Four Seasons*.

At over eighty years old, Akira is finally thinking of declaring his missing son dead.

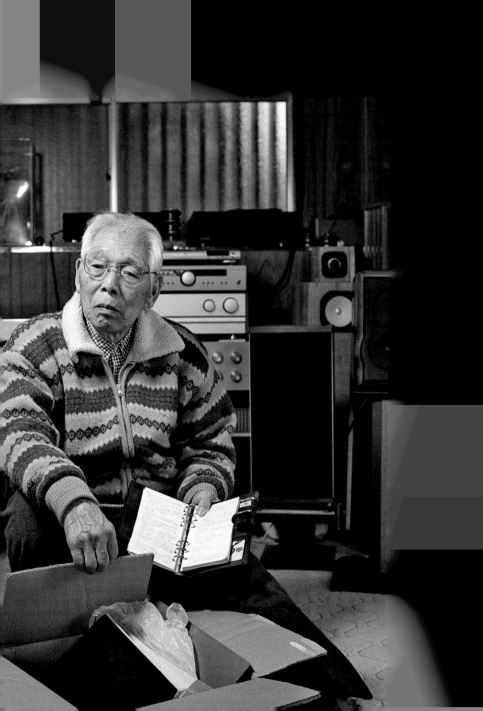

19

Teruo
Reappeared after two years

"I am not a man to be pitied. I can't stand pity. I won't tell my whole life story. It's not finished. Too many people already know my faults. Some must think I've fought, killed. They'll be disappointed. Thug is a job like any other. I got into the profession through the backdoor. I was in charge of housework, shopping. Cleaning up, sweeping, keeping the offices clean, a bit of a handyman, you know. A yakuza boss had spotted me in the street. I had been roaming around the same neighborhood for days. He noticed I was smart, not too badly educated. He said, 'I'm going to make you the new apprentice.' That's how I found myself in the clan. A lot of guys went down the wrong path really

young. Sometimes spent time in prison. Their lives were a boat with a leak, filling up with water. The mafia saved them; it's a paradox.

"The bosses taught us rules to follow with specific codes for everything: the salute, the attitude, how to talk, how to listen to people. We learned discretion, diplomacy, and especially loyalty—accepting the idea of dying for your clan. Evidently, discipline worked more or less well for those guys, who grew up around violence; it suited them, but they could explode at any time. After that, either you stay an underling, or you climb up the ladder. If you pass these steps, you can quickly gain new responsibilities, which is pretty exhilarating, like it is in any company. But you have to know how far you can go. People don't know their limits. Or else they reject them.

"I didn't work in prostitution or in gambling, but in the building sector. It wasn't always honest, but it wasn't sleazy either: a job like any other, really. But I knew if I kept moving up, I would reach the point of no return. When you attain a certain level of wealth, your head gets clouded with fake problems and convinces itself that money is the only solution. I saw guys get lost in that vicious cycle: they wanted to retire, tired of being thugs, but didn't want to give up the handsome suits, the car. And they dreaded pressure from the clan . . . What scared *me* was prison. I thought about it all the time. Night and day.

I was scared stiff of ending up in solitary. I think that's what decided it. In the old days, no one left the mafia. You could count the number of deserters on one hand. But times have changed. The yakuza aren't as rich and powerful. Another guy ran away before me, really young with his whole life ahead of him. The boss went crazy, sent people to find him on principle, to make an example of him, but at the end of the day, it was clear he could no longer force a man to stay in the family.

"One morning, I went to buy groceries and never brought them back to the office. The weather was great; the sun was already shining. It felt like I had climbed into a cave and emerged two years later. It was beautiful. But I was lost. After a few years in the mafia, where you are led by the hand, I had no idea what I was qualified to do. I had the plastic bag full of food and clothes I was carrying that day, that's it. Like a little boy who lost his parents in the supermarket.

"I sat down in a park, ate a little, counted the change from the errands, and bought a metro ticket. My old life was just on the other side of Tokyo. I sat down on the steps of my apartment, in the sun. I saw her silhouette in the distance, coming closer. She stopped about twenty meters away. I couldn't quite read the expression on her face, and since she wasn't moving, I got up to go over to her. It wasn't until we got in the elevator that she asked, 'Why did you come back?'

"Nothing had changed at home. Except my things, removed from the shared closet. That was one of the first things I did, go open the closets of the past.

"Two years I was away . . . It felt like I had been gone an eternity. And yet, when I found myself back in our studio, with my wife, it was as if it had only been a day. I didn't know what to say; I hadn't prepared anything. We had gotten married while at school. I'm two years older than her, so I had to look for a job first. At the time, I was reserved but demanding, I wanted an exciting life.

"At last, I had an opportunity in a packing company. But that didn't turn out well, with the competition and all that, so the boss said he couldn't keep me. That's when I lost my footing. I felt so worthless leaving the office that I wanted to throw myself under a train. I went looking for some tracks. The more I walked, the more scared I got. What if I ended up with crushed legs?

"My wife doesn't know anything about my time with the mafia. Would she still want me? I don't have a gift for imaginative stories, so when she asked me what I lived on, how I paid for my food without a credit card, I kept quiet. Now she wonders, fearing the worst, and I just keep rehashing my lies. They're eating me up. Talking to you today might help me ease them. That's why I agreed to meet you. Dealing with my

past alone. The present has no weight. It slips through my fingers like water.

"My father disappeared when I was really young. My family figured I was too fragile to go to the funeral. So I often dreamed my father was still alive and that they wanted to hide his disappearance from me to preserve his honor.

"My mother is a pretty cold woman. But when I returned to see her after my long absence, without warning her I was coming, I thought she was going to die of emotion, then that she was going to suffocate me, hanging off my neck. Next, she went over to the window. I don't know if that was her lookout, where she would wait for my return, or if she was worried which neighbors could have seen me, fearing the rumors that might start circulating around the neighborhood.

"The days go by at a crazy speed. I would be hard pressed to tell you how I spend them. It takes time to find your way. To find work, too. My wife runs the house; it can't go on like that. I know what the others must think: Teruo the burden, Teruo the incompetent. At first, I didn't go out; other people's stares burned me like red-hot iron. The desire to run away again scared me. Isn't that pathetic?

"I'm only thirty, and what now? It's easy to hide, a lot less easy to rebuild yourself."

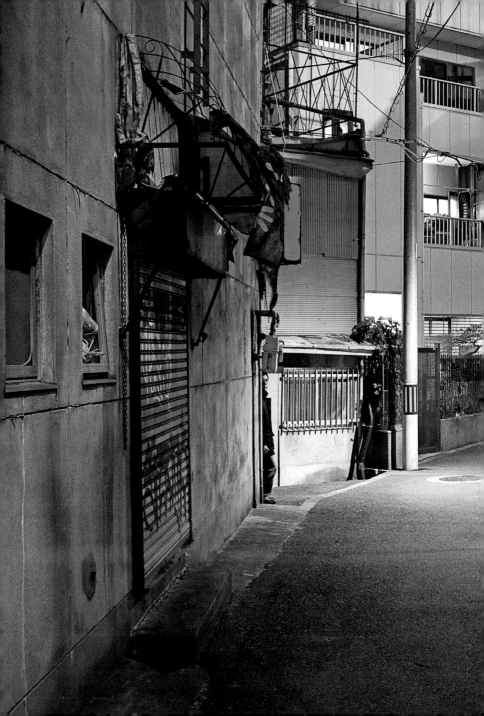

Kamagasaki, the neighborhood of the anonymous in Osaka.

This man, whom we met in a small hotel, is a former yakuza, disowned by his clan after an accident.

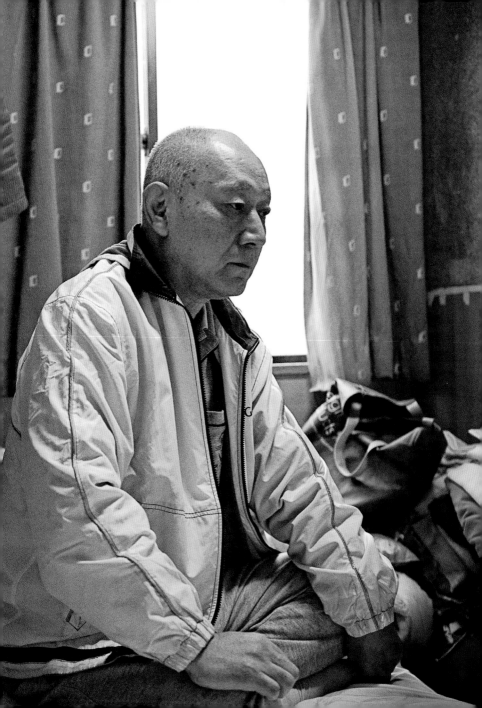

20

On March 11, 2011, we learn with the rest of the world about the apocalyptic landscapes on the northwest coast of Japan. Recorded on cell phones, a tsunami carries out its horror: remains of boats, cars, houses, port facilities, all of it backed by blaring sirens. Then the smoke rises: explosions, then radioactive material leaks from the Fukushima Nuclear Power Plant, for hours, days, entire months. The government equivocates in the face of the magnitude of the damage, unable to manage the emergency, and the residents are left to their own devices, helpless against the invisible harm they are condemned to suffer.

How far will the clouds, rain, wind, rivers, and currents carry the radioactive poison? How much of it will seep into the rice, potatoes, carrots, tea, seaweed, fish, animals, people? Foreign scientists quickly report traces of radioactivity in the air and water of several cities—Fukushima, Minamisoma, Sendai, all the way to Tokyo. Our Japanese friends do not know anything about it. The authorities have already decided to sacrifice entire populations. The government plays down the

risks, and TEPCO, the operator of the flooded plant, refines expensive—billions of yen—but reassuring misinformation.

That same weekend of March 2011, I find out I am pregnant. We have tickets to fly to Tokyo on March 23, but the flight is canceled. Three months later, and despite medical recommendations, we put down our bags in one of the shelters for poor workers in Kamagasaki, the neighborhood of the nameless in Osaka: eight stories, long corridors that smell like cold soup and fish, rooms furnished with creaking beds, a wardrobe, and lifesaving air conditioning, with communal bathrooms on the first floor. On the door of the appallingly slow elevator, a notice, probably printed by the state, encourages conserving electricity.

Wolfgang Herbert, known as "Wolf," appears behind the automatic doors of the hotel. In jeans and a T-shirt, his face youthful, he kisses us like we are old friends. I have never met Wolf before, but he has described to me, via Skype, his life as an Austrian sociologist, specialist on the Japanese mafia. Wolf, fifty-four years old, immersed himself in the lives of the day laborers and the yakuza. His story, even from a distance, foreshadowed another look at the dregs of Japan, and this professor at the Japanese university was happy to accept the challenge of finding the missing people among them.

The city wakes up slowly, already engulfed by the heat. Sweaty bodies seek shade along the low walls. The bell of an old

232

bike, loaded with bags of empty cans, chimes in rhythm with the potholes. We immediately recognize Kama's atmosphere, that desolate face of a schizophrenic country. As for Wolf, he fidgets, excited like a little boy. The Austrian, blond and white, greets those whom people no longer see, chatting to find an address here, an anecdote there. A bowl of noodle soup, gulped down in a cheap restaurant, and he is back on the streets, head high, chest pumped, eagerly taking on his role as scout.

Between shop stalls and little hotels, reinforced doors stand out, sometimes decorated with gilding. Wolf tries to count them—about twenty in a hardly two-square-kilometer area— and points out their guards, twenty-year-old tattooed gangsters, pacing back and forth, impervious to the filthy surroundings. "The yakuza get bored, too," he says. Every man protects a little illegal business generating nice profits on the black market.

The Japanese underworld is "far removed from the upper-middle class" where Wolf came from, descendant of Austrian doctors, engineers, and musicians. As a young man, he shined doing karate. Austrian champion, winning prizes in his category three times, he was invited at twenty-three to a competition in Japan. At the airport, several big Mercedes were waiting for him, along with his Japanese teacher from Vienna: at the wheels, old friends, all former members of the karate club at Takushoku University in Tokyo. Muscular,

disciplined, and used to the hierarchy, the karatekas, poached by the underworld, had earned their mafia stripes one by one. For days, thugs led Wolf from hotel bars to licentious parties. "That was my first impression of Japan."

Years later, the philosophy student was teaching Japanese over the summer in a private school in Vienna that hosted exchange students from Osaka. He got along with one of them, the daughter of a mafia tycoon nicknamed the "man who never sleeps" and number two in the Yamaguchi-gumi clan. Approached to replace the mafia godfather, the father of Wolf's student was subsequently gunned down at the bar on the fifth floor of Kobe's Oriental Hotel. Guided by fate, twenty-eight-year-old Wolf, reader of Pierre Bourdieu, turned toward partic- ipatory sociology and left his comfortable life to rub shoulders with the horde of day laborers in Kama. The neighborhood was still buzzing, turbulent and boisterous, with scores being set- tled out in the streets. One night, the sociologist met Ken in a food shop. The two men talked karate, tattoos, and gangsters, then left to go drink late into the night. The Austrian's chest is still puffed out in pride. "I'm not very tall, but at the time, my muscles spoke for me: don't fuck with me."

Ken the gangster served as a henchman to one of the Yamaguchi-gumi clan's right-hand men. He did not make a name for himself at school, but by playing boss with his

bodyguards. His life as a thug was made up of three routine blocks: ten days in the bars of the Osaka Minami sector, another ten days doing accounting in the office, and the last ten days making the rounds in Kama. Flanked by his minions, he would go into extended-stay hotels, shops, small restaurants, order a drink, a dish, joke with the boss, then take his tax, generally 10 percent of revenues. Sometimes Ken would charge for the ice, the napkins, the plants, or the frames as an indirect tax. There was neither debate nor fight—no one rebelled. In exchange, Ken and his clan would offer their protection, a sort of private police for kicking out irritable drunks and threatening people who would not pay. They knew everything about everyone, the rich and the poor, the living and the dead. The sociologist stresses this "give and take" exchange, the key to the mafia's influence in the country. It was only after Ken exclaimed one day, "You know, my organization is very international" that Wolf realized he represented "a validation, a passport, the proof of his clan's power and universality."

On the tray of a cart vendor, a group plays *Hanafuda* cards. A fat man with a missing knuckle and a guy wearing a cap and a gold chain stood in the same spot last year during our visit with Jun, our frightened interpreter. Wolf, sure of himself, radiating pride, walks toward them quickly, converses, and shows them the tattoo on his shoulder. The gangsters can threaten, but

Wolf knows the "code of honor," he assures us. Evidently, the sociologist feels at home in Kama, not only as a researcher, but also as a regular with an empathy for this ugly world.

Wolf simply asked the gangsters if they could answer a few questions from journalists. Since he knows the codes, the sociologist anticipated the mafia's refusal, but he tried, as he had already tried before our arrival with the Yamaguchi-gumi bosses. At the time, his contacts had hinted that the evaporation problem did not bring them honor. Nobody boasts about doing dirty work. Ken, Wolf's gangster friend, cannot tell us more about the sleazy practices pushing men to disappear. His brain is not working very well anymore, burnt out by the chaos of life: a mess of break-ups ("The yakuza fall in love, too," Wolf explains), brawls, drugs, prison, and on top of all that, a cerebrovascular accident, leaving the former thug half-paralyzed.

The evening breeze again burns our skin, sticky with sweat. Sitting on a low wall, panting, the Austrian admits, "Do you know why I feel comfortable here? Because I'm like them: I'm part of the minority. They are like foreigners in their own country, and they accept me . . ." In Wolf's opinion, a Japanese man who evaporates is first and foremost a man who refused to follow the main path, a black sheep, a maverick in this society where everyone clings to the norm and the imaginary

ladder of promotion and success. His perspective coincides with that of Stéphane, who sees the world idealistically, like a battle in which you choose whether or not to participate: accept the rules of the game, master them to better navigate it, or get out of the system. It is better, then, to give up comfort and live only with the essentials, to free yourself from the superfluous and remain peaceful in nature, safe from people. In a cabin somewhere in Brazil, as he had dreamed.

Under the pale light of the streetlamps, Wolf leads us through his memories. We blindly follow him through the outskirts of Kama, on the border of Osaka's two worlds, "just to see." Lanterns hang at the entrance to an alley, like leftover Christmas decorations sold in summer, or the entrance to a little carnival. Along the street, a row of beautiful wood houses with grey tiles showcase, through glassless windows, little illuminated rooms with floors covered in cushions shaped like candy-pink hearts, stars, and clouds, sometimes with a few lamps and plush toys, too. Women in traditional hairstyles, chignons held with clips, hold the place of honor in kimonos revealing low necklines and bare legs. Idle, silent, resigned, they gaze at their expressionless faces in hand mirrors, supervised by madams attracting customers.

When Wolf lived in Kama in the late 1980s, the day laborers ended their week of construction work by treating themselves to the pleasures of young girls, and the Tobita district

survived on the dismal sexual union of muscles enslaved by market forces and sad beauties subjected to men's fantasies. But these girls, though within reach, became too expensive for those who made a living on physical labor alone. The clients now look more like shy penguins in their tight suits. The madams dictate the prices, and the girls lead the men off down a little staircase. Clusters of curious onlookers pass in front of the brothels like tourists in Amsterdam's red light district. But here, the girls are dressed like engravings. Even in prostitution, tradition and modernity are entangled. Photos are forbidden, and communication with the girls is prohibited. We turn back.

Further on, a dandy plays guitar under the moon. Appearing from around the corner, he walked along the labor market hangar, and sat on a cardboard box near an old man hidden behind a big umbrella. The old man raised his head above his makeshift shelter, and the dandy began to strum a jazz tune, briefly pulling Kama out of its nightmares. Wolf knows one of the rare men to have plumbed the soul of the ghetto and its shadows. Since 1975, Arimura Sen has taken care of lost souls. The fifty-nine-year-old social worker, with an athletic stride, a mustache, and small glasses, works to save the fallen from their slow drift.

He walks with a bounce in his step toward some men sleeping on cardboard boxes, completing their sentences,

encouraging them to stand up with the help of their thin walking sticks. At his frank and cheerful interaction, tongues untie like magic, alcohol-soaked bodies stand up; one pulls a crumpled paper from his pocket and gives it to him. Arimura—Kama's memory, confidant to the lonely—inspires trust. "People come here to cut ties with society, but this becomes their neighborhood. After decades, they no longer need to hide." A toothless old man hurries toward us with three candies in his hand. Skeletal, he wears an oversized green sweatsuit, riding up over his T-shirt. Arimura questions him, and the elderly Hatsuo agrees to take us to his place, a hotel room, cluttered with knickknacks and stinking like the sewers. He offers us his futon as a seat and lays out his past in one breath.

Brought up in a modest family, he worked from the age of sixteen in a sewing machine factory. The wages were good, and yet, one day, he disappeared with all of his savings, with no explanation. Hatsuo evaporated without changing his name. He wanted to change his life, that's all, and squandered his new life on gambling, alcohol, and other addictions. When he had nothing left, he wandered around following work assignments as a day laborer, gas inspector, factory worker at Toyota. He never married, "didn't meet the right

person . . ." These days, he has reached the end of the road. "Too old. At sixty-six, no one will want me now."

A past attempt to reconnect with his family had failed, the door shut in his face. Hatsuo must have turned on his heels. Recently, his sister wanted to meet with him. Their mother had just passed away, and Hatsuo was listed in the will. She left a message at Kama's mutual assistance office, which identified the concerned via the medical center. A social worker played go-between. The sister, now a mother of six and a grand-mother, runs a tea house. Hatsuo does not feel that his absence had tormented her much. Time numbs the separation, surely. They agreed to see each other again "maybe once a year."

Arimura Sen enters a small three-story mocha-colored apartment building. Following in his footsteps, we are struck by the smell of medicine and death, the stench unique to old peo-ple's homes; it follows us all the way to a spartan room furnished with Formica tables and chairs. Inside, three men gaze at the linoleum, staring into space. Arimura has a personal interaction with each, and Wolf explains that he is catching up with them, reassuring them, complimenting them on their appearance.

One, in an informal T-shirt, fiddles with his thin hands, wrinkled like parchment. He, too, left without a trace. Because of unemployment, of shame. A wife and a son left behind. They had a reunion once, but "there is a distance

between us now." For him, life is like a school chalkboard: black, it takes on the colors of chalk, knowledge, drawings, and dreams, erased too quickly by the sponge. All that is left behind is the black and the erased memories.

The man smiles. Yes, in spite of everything, he can say he had a good life. It was not a race on a straight track with a beginning, a middle, a goal, but rather a battle with hits, bumps, fleeting victories, and moments of defeat. He broke down, often, only to get back up even stronger, head held high, uncompromising. He chose this fight. Regrets have no place in Kama.

Across from him, Arimura Sen nods his head. The Kama man, or at least his archetype—ruined and toothless day laborer traveling on a bike with his bundle—has become a manga character. Arimura has published over ten comic books. He likes the Kama man just as he is, in all his harshness and asymmetry. That is how Arimura sees the evaporated: men on their own but free. Loneliness in exchange for an untamed freedom.

On a scorching evening, three ageless guys talk at the bar. They raise their glasses to hope. A tout has offered them work. Housing and food for at least two months. They will have to clean, sweep, throw debris in bags. Debris from the Fukushima power plant. Nuclear dust. Tomorrow, these runaways will become liquidators. If they never return, no one will look for them. "That's how it is. There's nothing you can do about it."

241

One of the evaporated remains empty-handed, having found no work at the day-labor market in Kamagasaki.

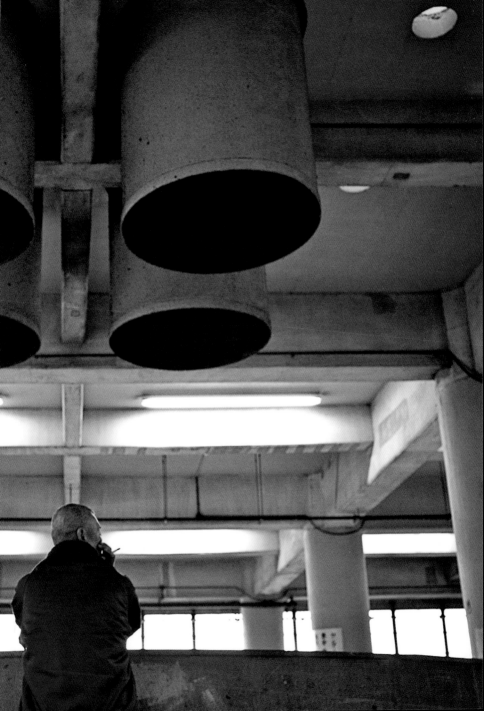

People come to Kama to cut ties with society, but it becomes their neighborhood. After decades, they no longer need to hide.

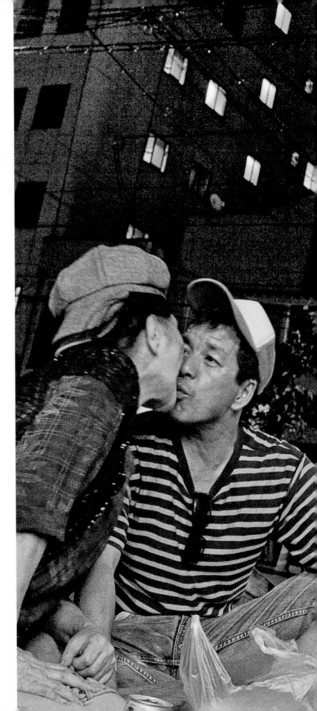

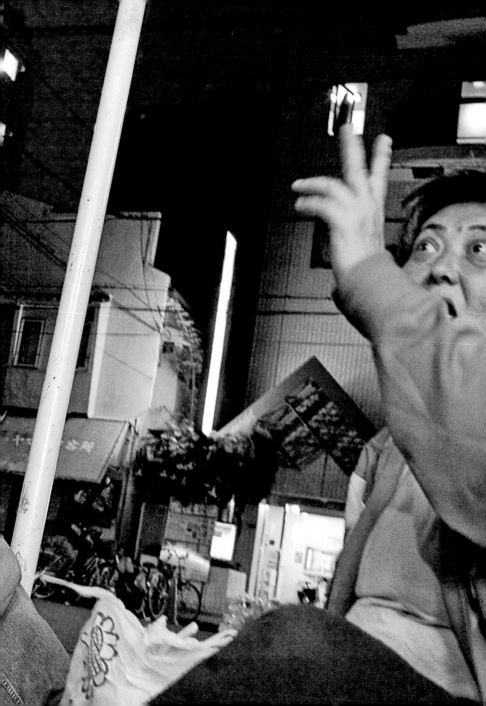

Epilogue

Everything is in its place. The cars are parked, the bikes are locked up side by side in front of the train station, the mail is slipped under the door. In the beautiful traditional houses left unlocked, the family photos on the walls are covered in mold. There is no more family. They are not coming back. Already the walls are crumbling, the roofs are caving in, the vegetation is slowly covering the buildings and ripping open the pavement. The region must have been beautiful. But something is wrong. Bags of radioactive waste, filled to the brim, are stored in front of houses, on the football field, or next to the town hall. I spent hours wandering around the city of Odaka until nightfall without coming across a single person. The silence was broken only by the cawing of the crows and by the absurd crackling announcements playing from loudspeakers: "We are a great nation. We will recover quickly. Stay proud and joyful!"

I left Léna in Paris to come photograph Fukushima's aftermath, to follow in the wake of the disaster and hear what

the residents have to say. But they deserted. There is nothing left to see, only abandonment. How do you photograph a void? The cities are desolate; life has gone elsewhere.

I saw the power plant from a few kilometers away, low and insignificant, as well as vans carrying men in white, masked, helmeted, anonymous, and silent. The government restricted three zones, as if radioactive clouds respected borders, as if people could control the smoke, dust, or water that escaped from the plant.

There is no choice but to secretly enter the restricted zone, a perimeter of twenty kilometers, surrounded by guarded barriers. In the deserted parking lot of a supermarket, I climb onto the back of a pickup truck, followed by my interpreter. We ride for many minutes curled up and hidden underneath a canvas tarp that protects old fruits and vegetables that will be fed to animals. Naoto Matsumura has kept his word: he smuggles us past the checkpoint blocking access to the deserted village of Tamioka. At fifty-two, the man lives without electricity or running water on land owned by his family, rice growers for five generations. Naoto promised to stay here to take care of the last animals left behind, made wild once again. The dog he comes to feed makes me nauseous. Half-blind, it is dying, losing its fur and teeth. Nevertheless, the last man in Fukushima remains hopeful the dog will survive. Further along, he has

gathered starving cows, pigs, and ostriches in a pen. On the ground, quite dry for May, my meter shows 8.62 millisieverts per hour, when the legally allowed limit is 1 millisievert per year. The wind swirls up the radioactive dust we breathe in, but it worries only me.

Like a deep-sea diver, I emerge from the black abyss to join the sixty thousand inhabitants of Minamisoma. The joyless, sleepy provincial city seems to be living normally: employees with briefcases go to the office, workers restore buildings, retirees chat under trees in bloom. In front of a shop window displaying old-fashioned wedding gowns, I get in the small car of Hiroyuki Suzuki, a dashing seventy-three-year-old grandfather dressed like an eternal teenager. Since the catastrophe, and in spite of his age, he took on the responsibility of supervising a group of volunteers. Wearing masks and protective overalls, they collect dead leaves, pull up grass, and scrape off the topsoil, without knowing exactly how or where to store all of it. His Geiger counter indicates levels twice as high as the ones shown on the public counters set up in the streets. Hiroyuki talks to me about a mysterious highly radioactive "black dust" that he sees along the side of the road, in the downspouts. He does not hide his bitterness about the decontamination programs. The authorities are digging up the soil of entire suburbs, but the levels remain formidable.

According to him, large sums of money are diverted before ever being used on the ground. Corruption is winning. The residents, lost and misinformed, no longer know on whom they can count. And already the mafia is taking advantage. It is easier for them to recruit the people left behind, the homeless, the evaporated, to work in this disoriented world.

A few kilometers farther on, I find the same motionless landscape of barricaded houses, sometimes gutted and looted, of drawn drapes, of silent playgrounds. Hiroyuki explains that the people who lived in these neighborhoods, forced to pack up and go, have been cooped up in tiny, temporary houses on the other side of the city. Minamisoma is itself split into zones with invisible borders based on levels of radioactivity. But the overpopulated country does not have enough space to rehouse those displaced by the nuclear waste. The old man shrugs his shoulders: his street was not contaminated, but only people his age stayed behind. No more children, no more schools, no more future. For years already the plant has been leaking. For years the country has learned to live with it. The first cases of cancer are popping up, and abortions are on the rise for the "girls of Fukushima," stigmatized in other regions.

Standing in his vegetable garden, turned red by pretty cherry tomatoes, an old man admits he has lost his taste

for gardening. He is tired of cultivating his loneliness. His sons no longer bring his grandchildren to share the Sunday crop. The big family house, passed down from generation to generation, does not interest anyone anymore. His whole heritage, his history, his identity will be extinguished with his contaminated ashes. A forced disappearance. Oblivion inflicted by man's hypocrisy. Like in a science-fiction movie, an entire province seems doomed to evaporate from the map. I need to breathe. I'm going back home to my family.

Stéphane Remael

Fukushima's restricted zone, less than twenty kilometers from the plant, has been reclaimed by nature.

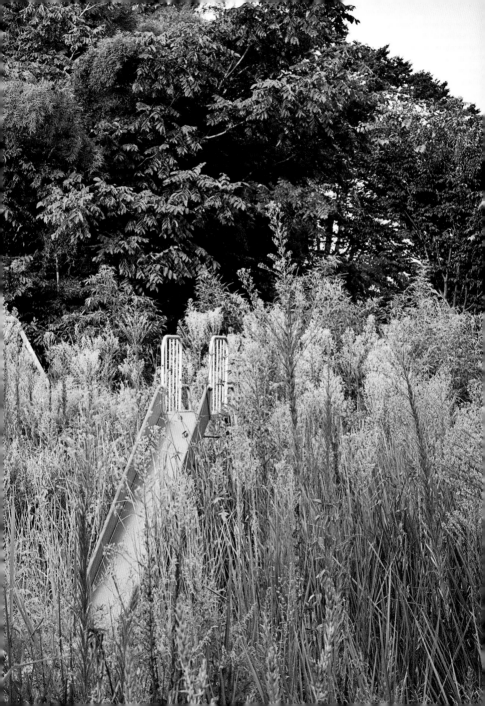

We would like to thank Patrick de Saint-Exupéry for publishing the first story on the evaporated of Japan in *XXI* in 2009, Laurent Beccaria for his patience, and Laurence Lacour for her meticulous reading. We also express our gratitude to those who confided in us, those who guided us. They know who they are.

At the request of certain people, names and places have been modified or left anonymous.